Norwich

MURDERS & MISDEMEANOURS

Norwich

MURDERS &
MISDEMEANOURS

Frank Meeres

AMBERLEY

First published 2009

Amberley Publishing Plc
Cirencester Road, Chalford,
Stroud, Gloucestershire, GL6 8PE

www.amberleybooks.com

© Frank Meeres

British Library Cataloguing in Publication Data.
A catalogue record for this book is available from the British Library.

ISBN 978 1 84868 457 7
Typesetting and Origination byAmberley Publishing
Printed in Great Britain

CONTENTS

THE SETTING — CRIME IN THE CITY

In the Middle Ages, Norwich was the largest city in England apart from London. It maintained this position until the eighteenth century, when it was overtaken by Bristol. In the nineteenth and twentieth centuries, many of the industrial towns and cities of the Midlands and the North have overtaken Norwich in size, but it has continued to be what it has been for many centuries: a county town with a market and a wide range of industries, and with a historic heart represented by its castle and cathedral, two of the finest Norman buildings in Britain.

A long tradition then, and one that includes centuries of work and play – and inevitably embraces its share of murders and misdemeanours. The history of crime and punishment has been played out here as much as in London or any other city. One aspect of criminality remained unchanged from the twelfth century to the late nineteenth: the role of Norwich Castle as a prison. However, in the Middle Ages a prison had a very different function – it was a place where criminals were kept while awaiting trial, not a place for locking them up afterwards. The major crimes were theft, rape and murder and the occasional forgery or treason. People accused of these offences might be locked up in the castle for months awaiting the king's judges from London. On the day of the trial itself, however, the process was extremely swift. If found guilty, there was no appeal: judgement followed immediately. There was only one punishment for serious crime and that was public execution. These cases were tried by the king's judges who would come up from London and sit in judgement. Later, this developed into the assize courts and a regular pattern of two visits a year to Norfolk, once at Easter and once in the summer. If you committed a major crime, how long you waited in prison for your trial would depend on when the assize judges were next in town, which could be a matter of a few days or could be six months later. The cases were heard before a jury. The jurors were landowners and were always male. No women were allowed to

serve on juries. This had consequences that we shall see several times in this book, as the defence counsel might appeal to male prejudices by attempting to impugn the moral qualities of a woman victim. Both prosecution and defence could challenge jurors before the case started, and they would be replaced by someone else from the pool of available jurymen. The verdict of a jury had to be unanimous, and if even one of the twelve dissented there would be a re-trial at the next assizes six months later.

From the fourteenth century another court developed, that of the Quarter Sessions. Local magistrates met four times a year to hear criminal cases, again in front of a jury. The major crimes like murder were still reserved for the assize courts, so the cases heard at Quarter Sessions would be mainly housebreaking and burglary in its various forms. The court did have the power to order the execution of those convicted but rarely did so after the eighteenth century. The most common sentences would be prison terms or, in the later eighteenth and nineteenth centuries, transportation to Australia, which might be for a term of years or for life. These cases were held in the Guildhall.

There were also a series of courts for lesser offences, the leet courts and, from the later Middle Ages, the mayor's court. These were the courts before which Norwich people appeared if they were accused of blocking the road with their rubbish or selling mouldy sausages at the market, and for these offences they were fined. After the Middle Ages, two magistrates would sit in judgement in these cases and there was no need for a jury – these are the courts known as Petty Sessions and were also held in the Guildhall. The magistrates held preliminary hearings in many of the cases in this book, and it was they who sent the accused on to their full trials before the assizes, if they were convinced that there was a case to answer.

As well as these courts, there was a separate system for dealing with cases of sudden death: the inquest. These were dramatic events in themselves and usually took place on the day after the death. The proceedings were held before the coroner; the jury, twelve local men, met together, viewed the body and pronounced on the cause of death, usually 'murder' in the cases in this book. If they were sure who had committed the crime, they might actually name the murderer. These inquests were held in a large room near to where the death took place. This was most commonly the local public house, so that a great many city pubs have served this macabre function. Many later Victorian inquests were held in the Waterman pub in King Street, at the bottom of Horn's Lane, as this was opposite the local mortuary where the bodies were stored. If the death had occurred in the Norfolk and Norwich Hospital, the inquest would be held there instead.

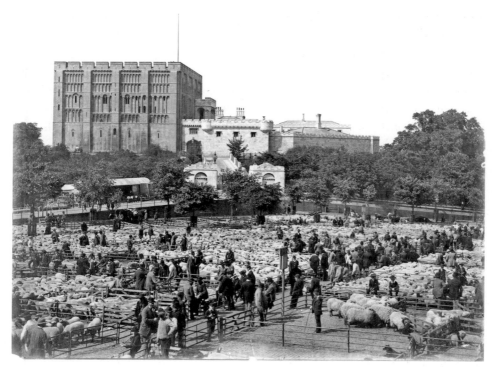

1. Norwich Castle and cattle market. Public hangings took place between the two lodges (NRO, MC 186/84/3/8).

One other authority also held trials: the Church. People who were clergy (and this included a large number of people – all men – in the Middle Ages) could claim the right to be tried by Church courts rather than civil courts. The bishop had his own prison, in the cellar of the Palace Gate. The Church also had the right to condemn anyone who committed heresy – that is, held opinions on religious matters not in accord with the teachings of the Church authorities of the day. This was not a trivial matter, and in extreme cases it could lead to a capital punishment, such as being publicly burnt at the execution place known in Norwich as the Lollards' Pit. Although Church courts are associated with the distant past, they do occasionally still have a dramatic role to play, as in the case of the notorious rector of Stiffkey in the 1920s, which is discussed in the Norfolk volume of this series.

The hangings usually took place in front of the castle, but this was not the only place of execution. Hangings might take place on the spot where a crime was

actually committed or at other places outside the city gates, especially at the Town Close outside Saint Stephen's Gate. Another common practice was gibbeting, where the criminal was executed and the body then hung in chains in some public place as a warning to other potential wrongdoers.

From the fifteenth century, Norwich was a county in its own right. This meant a separate legal system. The castle continued to be the prison for county offenders, but another prison was needed for city criminals. This was at first (from 1412 to 1597) in the cellars of the Guildhall and later on Gaol Hill, just a few yards away. In 1826, the new purpose-built City Gaol was opened. It was outside Saint Giles Gate, at the junction of the Earlham and Unthank Roads (the Roman Catholic Cathedral now stands on the site of this prison), and hangings took place there too.

These hangings were public spectacles and could attract an enormous crowd. Those at the castle took place between the two lodges at the bottom of the bridge. One execution happened to be on the same day as Tombland Fair, and the crowd was estimated at about 30,000. The local newspaper described the scene after the moment of death: 'Gongs, drums and other instruments commenced their uproar, mountebanks and clowns their antics, the vendors of wares and exhibitors of prodigies their cries, while the whirligigs and ups-and-downs were in full swing. The public houses round the Hill were crowded, and hundreds finished the day in riot and intoxication.' On one occasion at Nottingham, fifteen or sixteen people died in the crush of a crowd watching a public execution.

The last public hanging took place in Norwich in 1867. Later, Victorian executions took place within the walls of the two prisons, but crowds continued to gather outside, a black flag was hung and local church bells were tolled, so that a hanging was still an occasion for spectacle. Later in the book I describe the scenes at the Stratford and Sheward hangings at the City Gaol as examples of what such occasions could be like. The City Gaol was closed in 1878 and the prisoners moved into the castle as a temporary measure. In 1887, this finally closed to be replaced by the present prison on Mousehold Heath, and the castle became a museum. The 'new' prison was designed for both male and female prisoners, but since 1924 it has only housed men, the women being transferred to Holloway prison in London.

Lesser 'criminals', such as the idle, beggars and unmarried mothers, might be sent not to these prisons but to the Norwich Bridewell, as we shall see in the case of Jane Sellars. However, this also closed when the new City Gaol was built in 1826, and it too is now a museum.

How do we know what happened in the past? Ultimately this depends on the survival of documents. The records of the assize courts are now in the National

Archives in London. Records of the lower courts and inquest records are held at the Norfolk Record Office, as are many other documents telling the story of the county's history. Local newspapers which describe the crimes and the court cases in great detail from the nineteenth century onwards are held in the Norwich Heritage Centre.

'SAINT' WILLIAM OF NORWICH

The earliest murder in this book is also perhaps the most famous, and after over 850 years it is still much discussed. A certain amount is known about the victim but we have no idea who the killer or killers were, and we can only be sure that those (a community, not individuals) whom popular rumour associated with the crime were entirely innocent.

Early on the morning of Easter Saturday in 1144, the body of a boy was found by a woman in a thicket of bushes on Mousehold Heath. He was dressed only in his jacket and shoes and his head was shaved and was covered with what appeared to be a large number of stab wounds. However, the cause of these wounds soon became apparent as the woman then saw two ravens land on the boy's head and start to peck at it. She does not appear to have done anything about the discovery at once – very likely she was there illegally gathering fuel, which was a serious crime in those days. In fact, the next person on the scene was the forester patrolling the Heath, a local man called Henry de Sprowston. He formally inspected the body and found a wooden gag thrust into the boy's mouth, along with other signs of violence. He took the necessary steps, including asking the vicar of Sprowston if the boy could be buried in his churchyard when the Easter festivities were over. However, on Easter Monday Henry changed his mind and had the body buried where it lay on the heath. As this was unconsecrated ground, this may well have been a temporary measure to prevent further decay and attack by vermin.

On the following day, the body was identified as being that of a twelve-year-old boy called William. We know quite a lot about William because a monk at Norwich cathedral, Thomas of Monmouth, wrote a book about him in about 1170. Thomas did not come to Norwich until some years after the crime and his book was written a quarter of a century after the event, but he knew many of the people involved so his book is likely to be reasonably accurate – at least in its details about William's short life.

William was born on 2 February 1132, almost certainly at Haveringland, a small village 8 miles north of Norwich, as he was definitely baptised in the parish church there. His father was called Wenstan and his mother Elviva, the daughter of a married priest. He had at least one brother. An uncle Godwin and an unnamed aunt also feature in the story. Godwin was a priest and his own son, Alexander, a deacon, so there was a strong religious background in the boy's early life. Apparently, he enjoyed going to church and learning his letters and psalms and prayers, which was probably all the formal education that he had. Wenstan died while the boy was still very young. William began work at the age of eight – a fact that seems extraordinary today but was perfectly normal in his time. He was apprenticed to a skinner, at first, apparently, in the country, but he soon moved to Norwich where there would be much more opportunity for a craftsman. In fact, there was a whole community of skinners around the Rose Lane/King Street area; the modern street name 'Mountergate' derives from the word 'parmenter gate' – literally, the street where the skinners lived.

One day a man came to William saying that he was a cook for the Archdeacon of Norwich and that there was work for William in the kitchen. The two discussed the matter with Elviva, who appears to have had doubts about the man but who eventually allowed him to take William away. This was just a few days before Easter in 1144. William was now twelve years old; his family never saw him alive again.

Godwin was aware that his nephew had disappeared, and when he heard that the body of a boy had been found on the Heath he naturally feared the worst. He went to the spot with his son Alexander and William's brother. They dug up the corpse and identified it as William. Godwin took the gag out of the boy's mouth and kept it, and they then reburied the body on the same spot.

Thomas of Monmouth talks about Elviva's grief and anger at the death of her son in words that have the power to move the reader over 800 years later: 'With torn hair and clapping of hands she ran from one to another, weeping and wailing through the streets like a mad woman... Sometimes she behaved like a mother moved by a mother's love sometimes she bore herself like a woman with all a woman's passionate rashness'. In her grief she appeared to be able to accept a nasty rumour that someone was spreading in the city: *perhaps* the murder had been committed by members of the Jewish community?

The background to this idea needs some explaining. Norwich was one of the largest cities in England at this time, and, like most big cities, it had within it a Jewish community. The Jews tended to live close together for security. Many of their houses, including their synagogue, were between the Market Place and Norwich Castle (if you shop in Primark today, you are standing where the synagogue used to be). However, this was in no sense a ghetto: people of both

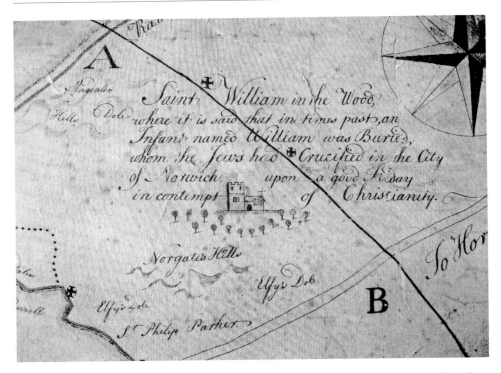

2. Copy of a sixteenth-century map showing the place where William's body was found (NRO, MS 4546).

communities mixed freely in the streets, and one well-known Jewish family lived not there but in King Street, in the building now called Wensum Lodge. The cellar here (now a bar) is that of the house of the Jurnet family. The Jews had various trades: some, for example, were doctors practising herbal medicine (one of the first known herb gardens in England adjoined White Lion Street and was owned by a member of the Jewish community) and others lent money (Jewish communities were the banking institutions of their day, and without their financial support, great buildings that needed huge capital investment like Westminster Abbey, Bury Saint Edmunds Abbey and Norwich Cathedral itself, could probably never have been built). The communities in Norwich got along pretty well together on the whole, but occasionally violence would flare up between them. One such flare up had occurred very recently, in the 1140s. A Norwich Jew called Eleazar had been murdered by a Norfolk knight who owed him a lot of money, so that tensions between the two communities were running high.

Once the rumour spread that William could have been murdered by members of the Jewish community, some were only too willing to believe it but a great

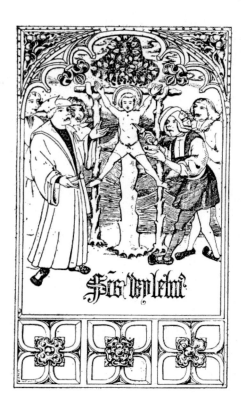

3. *Engraving based on the image of
William in Loddon church.*

many people did not. The Bishop of Norwich, Eborard, certainly did not believe
the story, although the prior of Norwich Cathedral was prepared to do so. When
Eborard retired in 1146, the prior became bishop, but now *his* successor as prior,
Elias, was totally unconvinced of the truth of the story. Only on the death of Elias
in 1149 did things begin to develop. William's body had been buried in the monks'
graveyard. It was moved into their chapter house in 1150, into the cathedral itself
in 1151 and into its own chapel in 1154, which is the round chapel to the north of
the high altar, now known as the Jesus Chapel. Miracles of healing were alleged to
occur at the shrine, and these were naturally boosted for all they worth by Thomas
of Monmouth and by the cathedral authorities, as miracles meant pilgrims and
pilgrims meant income. Every cathedral and major church aspired to possess
the shrine of a saint. That of William was, in fact, not to prove a particularly
successful money-raiser. The healing stories, briefly popular in the 1150s, had
already begun to decline by the time Thomas wrote his book, just twenty years
later; by the 1340s, the amount left at the altar by the pilgrims was derisory – in
one year a mere 4*d* was given!

The saddest aspect of the murder is that it was the first of what was to become quite a common occurrence throughout Europe, when the finding of a murdered boy became associated with the local Jewish community. A few crazy people even came to suggest that there was a conspiracy by which European Jews met each year to select a European city where a boy was to be killed in a grotesque parody of the crucifixion of Jesus. This, sometimes known as the Blood-Libel, was not believed by anyone with any sense but could become a dangerous thought when used by anti-Semitic rabble- rousers, such as, for example, some in Nazi Germany in the 1930s. In this context it is worth recalling that when Jewish children fled from persecution in Germany in the late 1930s (the so-called *Kindertransport*), Norwich was one of the places where they were made welcome and cared for – a fact in which the city can take great pride.

It is still possible to make out humps and bumps in the ground that mark the site of the chapel built on Mousehold Heath in the 1160s, which itself stands on the spot where the body was found on Easter Saturday 1144. This is a good place to think about how easily false rumours can start and what a terrible effect they can have on the lives of totally innocent people.

TWO NUNS AND A MURDER

In 1415, William Koc of Trowse was murdered in Lakenham by a gang of seven men armed with spades and sticks. We do not know the motive, but they were clearly out to make sure that he died. They attacked him at 8pm on 16 August 1415. William Coteham gave him a fatal blow on the head with a mole spade. John Feversham, William Wright and Thomas Grenefield followed up with blows with their staffs, any one of which would have been enough to kill their victim. His widow Margery raised the hue and cry – that is, she made the neighbours turn out and chase the criminals (in the days before a police force this was the only way that criminals could possibly be caught). Her party searched in the four neighbouring townships, but to no avail. There was a simple reason for this: the murderers had wound up in the house of nuns at Carrow Priory (known incorrectly to locals as Carrow Abbey), on the road between Lakenham and Norwich (the priory owned a good deal of land in Trowse and Lakenham). Either they sought sanctuary in the priory or they had been taken there by the prioress' servants. The dispute became a legal one – the Norwich authorities claimed the right to try the men, but the prioress of Carrow said that it was *her* right to do this and that Lakenham was technically not in Norwich. There was a bizarre consequence: the prioress, Edith of Wilton, and one of the other nuns, Agnes Gerbald, were themselves accused of harbouring the murderers and even found themselves imprisoned within Norwich Castle! Eventually the nuns were found not guilty of any crime. The gang members appear to have fled, so that Margery's efforts on behalf of her husband were in vain. Coteham eventually received a royal pardon – due to a legal dispute, he had literally got away with murder.

THE MARKET PLACE

The Market Place has been the scene of many misdemeanours over the last seven hundred years. In May 1309, a man tried to sell a pair of socks there. Nothing unusual about that? There must have been something unusual about the socks themselves as the market traders recognised them! They had belonged to a man named Brice who had recently been murdered in Tunstead. The man was arrested on suspicion of the murder. He was Geoffrey de Stanford of Crostwight. He had to wait two years in prison in Norwich Castle for trial and when the case finally came up in March 1311, Geoffrey was acquitted of the murder. Another attempt to sell stolen property in the early fourteenth century also had bizarre circumstances. Andrew Friday from Raveningham sold a horse to Peter Munk in the Market Place. Munk bought it for a bargain 8s – it was worth 20s. Suspicions were aroused by this and it was found that Friday had stolen the horse from someone in his home village and brought it into the city to sell. However, the jurors also found that there were complications in the case. Friday was a lunatic in the most literal sense of the word – he became insane as the moon waned each month. Just a fortnight before the theft he had apparently cut down the trees at his house and replanted the trunks in the ground at a different place, expecting them to grow there. While he was in Norwich Castle awaiting trial, he had torn with his teeth his own clothes and those of other prisoners. The jury was convinced. Had he been sane he would certainly have been hanged, but because of his insanity he was sent back to prison to await a royal pardon. And the suspicion, even after 700 years, is that he just *may* have out-bluffed the jurors!

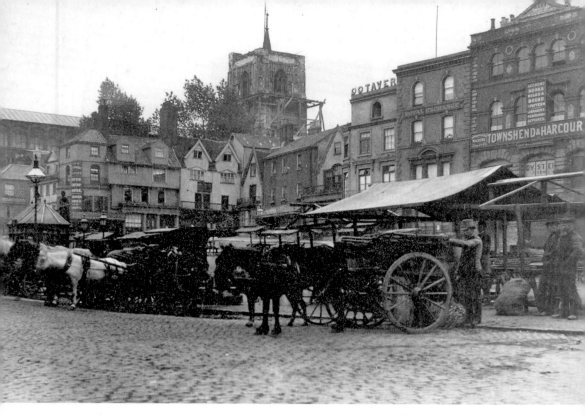

4. Norwich market place in Victorian times (NRO, MC 186/3/9).

LORD EDWARD SHEFFIELD AND ROBERT KETT

The only murder victim who has a plaque in Norwich is Lord Sheffield, murdered on Bishopgate on 1 August 1549. His murder was just part of a series of events that disrupted Norwich life throughout the summer of 1549 – Kett's Rebellion. Robert Kett led a group of mainly working men and women in a peaceful protest against the establishment, especially against conditions in the Norfolk countryside. His long list of demands included the well-known phrase 'We pray that all bond men may be made free'. They set up a camp on Mousehold Heath. If you want to know where this camp was, look up from the centre of Norwich towards Thorpe. You will see a large white water tower on Thorpe Heights – this is on almost the exact point of the camp where Kett kept discipline by sitting beneath a large oak tree and administering justice to his many followers.

Naturally, the authorities could not allow the protesters to remain indefinitely. An army came to defeat them, led by Lord Northampton and his deputy, Lord Sheffield. Kett's men decided that attack was the best form of defence. The rebels had cannon on Thorpe Heights with which they attacked the city's defences, and the damage still visible at the top of Cow Tower is supposed to have been caused by Kett's gunners. His men came down the hill, across Bishop Bridge, and got as far as Tombland before they were driven back. It was during these skirmishes that Sheffield was killed. Does a death in battle qualify as a murder? The authorities certainly spun it as a crime against the state. According to their story, Sheffield attacked bravely until he was dragged from his horse (note, however, that he was on horseback, which must have given him a great advantage as Kett's men were fighting on foot). A local butcher and carpenter named Fulke promptly dispatched Sheffield; his body was later buried in the nearby Church of Saint Martin at Palace with thirty-five other soldiers.

Northampton fled and Kett's men set fire to many houses in the city. Kett's enemies much exaggerated this event. One opponent wrote 'Lamentable and miserable was the state of the city: when nothing was seen or heard, but lamentation and weeping of those that were vexed and troubled; and on the other

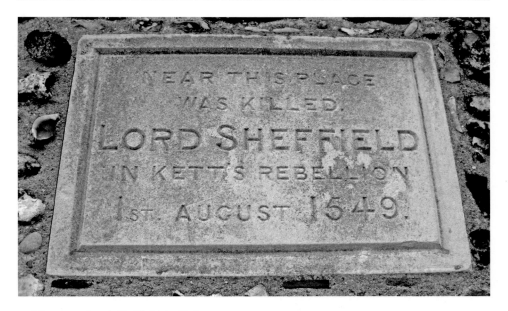

5. *Plaque to Lord Sheffield in Bishopgate.*

side the rejoicing of the enemy: the weeping of women, the crying of men, and the noise of those that ran about the streets; then the clashing of weapons, the flames of the burning, the ruin and fall of houses, and many other fearful things which (that I may not tell in full) I willingly let pass, which so filled with horror, not only the minds and eyes of the beholders, but struck with incredible sorrow the hearts and ears of all that heard it.' Just because something is written, does not necessarily make it true (a lesson for all researchers). In fact, it was raining heavily and this prevented the fire spreading among the houses.

After this, the rebellion was taken more seriously by the authorities and a professional army under Lord Warwick was sent to defeat Kett. This army marched through Norwich, hanging any supporters of Kett that they came across upon the cross that then stood in the Market Place. They finally met up with Kett's followers at Dussindale on 27 August. People are not sure where this was. The city authorities have decided that it was east of Norwich and there certainly was a field called 'Dussin's dele' there in the eighteenth century. However, the sources say that the battle was north of Norwich, and I agree with local historians like John Kirkpatrick that the site of the battle was actually in the Long Valley on Mousehold Heath. The valley would not have been covered in trees as it is today, as in those times animals grazing on the heath would have kept tree-growth down. The 'battle' was in fact more like a massacre – professional soldiers against

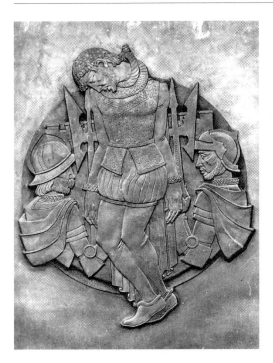

6. Bronze depiction of Kett's execution on the doors of City Hall.

peasants armed with pikes. Realising defeat was certain, Kett had already fled from the battlefield. He was caught hiding in a barn at Swannington. After a trial in London, he was brought back to Norwich on 1 December to be executed there. He was kept in chains in the Guildhall for six days. On the morning of 7 December, he was taken to Norwich Castle and there hanged in his chains. His body was left hanging from the castle wall and remained there for months, visible to local people doing their shopping in the nearby Market Place. Many of his supporters were also executed, Fulke among them.

Kett was regarded as a villain by many people, especially the middle and upper classes, but to many poor people he was a hero, and the camp on Mousehold Heath was remembered in the city as a golden time. In the last century, many more people began to see Kett as a local hero. There is now a plaque to him on the side of Norwich Castle, to balance that to his enemy Lord Sheffield near the Adam and Eve public house. He is also remembered on the bronze doors of City Hall. Kett and Sheffield, which was the murderer and which the victim? That depends on your own political viewpoint.

LOLLARDS AND OTHER MARTYRS

Lollards' Pit in Norwich is still a well-known spot in the city, just outside the old city gate at Bishop Bridge. Several people died a slow and painful death here in the fifteenth and sixteenth centuries, being burned at the stake before a crowd of onlookers. Their 'misdemeanour': being prepared to die for their faith. The most well known was Thomas Bilney. He was born in Norfolk and became a preacher, and in 1527 he was convicted in London for heresy and spent a year in prison. He took up preaching again and was arrested as a relapsed heretic in Norwich in 1531. He was put to death on 17 August 1531. He was held in Norwich Guildhall prison while awaiting his execution, and on the night before his death he is said to have tested his courage by putting his fingers into the flame of a candle in his cell.

It was not just men who were prepared to die for their beliefs: at least two Norwich women were sufferers at Lollards' Pit during the reign of Queen Mary. Elizabeth Cooper was a pewterer's wife who interrupted a service in Saint Andrew's church to express her protestant views; she was burned at the Pit on 13 July 1557, alongside a man called Simon Miller from King's Lynn. Their execution was watched by a large crowd. One of them was Cicely Ormes, the wife of a Norwich worsted weaver. She was so inspired by their courage that she exclaimed that 'she would pledge them of the same cup that they drank on'. After over a year in the prison below the Guildhall, she died bravely on 23 September 1558, and over 2,000 local people watched her execution at the Pit.

These people were Protestants but other people were equally ready to die for their Roman Catholic faith. These were often priests, and the dangers of their work can be still be imagined from the hiding places, known as priest's holes, like the one that can be seen at Oxburgh Hall. One such man was Thomas Tunstall, who had been caught and imprisoned in Wisbech Castle. He escaped by sliding down a rope but at the cost of badly blistering his hands. His wounded hands were tended by a kindly woman named Lady l'Estrange. Most unfortunately, however,

7. Saint Benedict's Gate.

her husband, Hamon, who was a justice of the peace, guessed who Tunstall was and turned him in to the authorities. He was imprisoned in Norwich Castle, and at the next assizes he was tried and sentenced to death. He was not, however, executed at the Lollards' Pit. On 13 July 1616, Tunstall was brought to Magdalen Gate in Norwich to be hung, drawn and quartered there. Seeing Hamon l'Estrange in the crowd, he at once forgave him, saying that he bore him no grudge. With grim humour, he asked if, after his quartering, his head could be placed on Saint Benedict's Gate, as he had a special devotion for that saint.

JANE SELLARS — CRIMINAL OR VICTIM?

This book is written mainly to provide an entertaining read but also in the hope that readers will think about what it was like to live in Norwich in the past and how they would have acted in the circumstances in which some of our characters find themselves. This is the true story of a Norwich girl, Jane Sellars, who lived almost 4000 years ago. As the story unfolds, ask yourself if Jane is a criminal or a victim and, at each stage, think about what treatment she would have received today. The story begins in June 1623 when Jane was discovered idling in the streets of Norwich. There is nothing to say she was begging, just being idle. Of course, merely to be standing about in a city street would have been unusual four centuries ago. When Daniel Defoe came to Norwich 100 years later, he noted how empty the city streets were on weekdays when everyone was at work. Jane suffered the standard punishment: she was whipped and sent to the Bridewell until she could find work with someone or – as it was then called – enter into service. She must have been let out of the Bridewell, as in April 1624 she was once more found idling in the streets. In Michaelmas of that year, she found a position, or perhaps the authorities found it for her, and a Mr Robinson of Yarmouth took her on for a year, the normal period of a work contract in those times. We have no idea what her treatment by Robinson was like, but clearly she did what so many young apprentices and servants have done over the centuries: she ran away. In April 1625, she was again a vagrant on the streets of Norwich. She got the usual whipping and was given a ticket to get back to Yarmouth and the service of Mr Robinson, but she obviously never went and just a few days later she was back in the Bridewell. She was let out in August and given two days to leave the city. She did not do so, and was picked up yet again in October and once again the following month, and each time there would have been a severe whipping before the inevitable confinement in the Bridewell.

Perhaps the decisive year in Jane's life was 1627. A master was found to take her on; she ran away. A second employer took her on; once more she ran away. In October, no doubt after the usual whipping, she was back in the Bridewell and

8. The exercise yard of the Norwich Bridewell.

the authorities were clearly losing sympathy; she was still there at Christmas in 1628. In 1629 she was convicted of an actual crime for the first time, and she was whipped for 'michery' (petty theft) and 'ill rule'.

All these appearances had been before the lowest level of criminal court, the mayor's court which is the equivalent to petty sessions. In April 1630, she appeared for the first time before the court of Quarter Sessions, a court for more serious crimes conducted with a jury and with the power to inflict more serious punishments, including ultimately the death penalty. She was charged with stealing six pairs of stockings.

By now, Jane had another mouth to feed: she had given birth to an illegitimate child. There was, of course, no unemployment pay and no child benefit of any kind in seventeenth-century England. She obviously could not function as a single mother, so the child was taken from her and 'put' to a woman in Saint Swithin's parish. The winter must have been an especially difficult time; in November 1630 she was twice whipped for lewdness and ill rule. The reference to lewdness suggests she *might* have been involved in prostitution, whether from choice or sheer necessity. In April 1631, she was up before the court once more, again on a charge of petty larceny, but for once in her life someone was kind to her and she was acquitted by the jury.

9. *The record of the execution of Jane Sellars (NRO, NCR 20a/9).*

In August 1631, she was caught begging and again sent to the Bridewell. Within a few days she was caught committing another petty theft (the value of the goods being under ten shillings), and this time she was branded. This punishment was given to repeat offenders and consisted of burning a permanent mark onto the criminal, usually on the left hand. Apart from the tremendous pain involved, it would mark Jane as a recidivist and make life even harder for her in the future. However, when she was released in October 1631 she promised the court that she would go at once to Yarmouth and get a service, not too easy for a branded woman.

All we have learned about Jane's life story has come through eight years appearances before the courts. Would this story of petty crimes and begging followed by whippings and confinements to the Bridewell go on throughout Jane's life? No, the authorities had had enough of tolerance. In December 1631, Jane was back in Norwich and the object of a terse note in the court minutes: 'Jane Sellars to be executed'. In the language of the nineteenth century, she was 'turned off'. Jane's age is never given in the records, but she may well have been in early or mid teens when she first came before the courts, and no more than her early or mid twenties when she was executed. Victim or villain? You decide.

'THE GREAT BLOWE'

The Civil War saw no battles in Norwich but it did see several murders and other misdemeanours, with considerable loss of life. Although the majority of people in Norwich were supporters of Parliament there were plenty of Royalists around the city and in the county. This led to attempted rebellions and harsh treatment of those who tried to support the royal cause. In April 1648, there was a riot in the centre of Norwich between Royalists and Parliamentarians. It was the Royalist supporters who rebelled against the supporters of Parliament, led by such men as William True, a dyer, Thomas and John Bidewell, two labouring brothers, and a mysterious man in black who was seen by several witnesses at key moments in the day. The climax of the revolt was an attack on the Parliamentary headquarters at the Committee House (where the Bethel Hospital stands today, just behind the Millennium Library). The rioters began by sacking the house of Sheriff Ashwell, a prominent Parliamentarian who lived next door to Saint Michael at Plea church. They then moved to the Committee House and surrounded it. The defenders fired on them, killing a boy and this outraged the crowd. At about 3.30pm, they broke down the gates and got into the house, in which guns and gunpowder were stored. Chaos ensued and one witness saw gunpowder spilt everywhere (he himself swept up a pound of gunpowder). Another man was seen running out of the building with his hat full of the powder. The result was inevitable: there was an enormous explosion which shattered the windows of houses and churches in the centre of Norwich, including the stained glass in the windows of Saint Stephen and Saint Peter Mancroft. At least forty and perhaps up to a hundred people were killed.

This disaster has become known to Norwich people as 'the Great Blowe'. At about the same time as the explosion, Parliamentary troopers arrived in the city to restore order. One man was seen throwing stones at them from Saint Stephen's churchyard and ducking behind the churchyard wall as the troopers retaliated. The authorities took strong action against the rioters, prosecuting no less than 108 people. The trial took place at the Guildhall on Christmas Day, 1648. The

10. Saint Andrew's Hall.

mysterious man in black was identified as a Norwich man named Henry Palgrave, but he had probably fled the city as he was not among those tried. Eight men were sentenced to death, including True and the Bidewell brothers, and others were imprisoned, fined or whipped. The eight were later publicly hanged in the Castle Ditches, alongside two women, Margaret Turrell of the Great Hospital and Anne Dant, who, in an unrelated case, had been found guilty of witchcraft. The Bidewells were buried in Saint Stephen's churchyard, thus this church, now one of the entrances to the Chapelfield Shopping centre, played an important part in the Great Blowe of 1648.

It might strike some readers as surprising that the trial took place on Christmas Day, but this was actually a deliberate gesture by the Parliamentarians. They wanted Christmas Day to be just like any other day, with the shops and markets open as usual and everyone going about their normal business. Under a law of 1644, it was forbidden to decorate one's house, carol singing was banned and mince pies and plum pudding (then known as plum porridge) were specifically banned on Christmas Day. The Norwich authorities, as good Parliamentarians, took this seriously and in 1645, they met on Christmas Eve to forbid all churchmen in the city to hold services on the next day. Two years later there were riots in the city

when the apprentice boys of Norwich gathered in protest – apart from religious convictions they naturally resented losing a day's holiday!

Christmas Day 1649 also saw a man on trial for his life in the city, this time in Saint Andrew's Hall. He was one of a group of local Royalist supporters who had taken part in an attempted rebellion on 7 October. Judges were sent down from London to try the 'rebels', beginning their work on Friday 20 December. They condemned six men to death on the following day. They were hanged in the Market Place on the Monday. Six more men were sentenced to death on Christmas Eve. On Christmas Day, it was the turn of Thomas Cooper of Holt to face trial, the main witness against him being one William Hobart. Cooper was sentenced to death and hanged at Holt a few days after Christmas. More death sentences were imposed over the following week, and one of those condemned was Hobart himself. Two more Royalist officers, Major Francis Roberts and Lieutenant John Barber, were hanged on a gallows in Norwich Market Place.

PASSIONS AMONG THE RICH AND POOR

Two 'spur of the moment' murders of about three centuries ago both took place around events in public houses. One arose out of an incident in the Maid's Head, still one of the most well known Norwich inns. It was the seventeenth-century equivalent of the knife crimes that are such a sad feature of twenty-first century urban life: two young men, armed, and easily aroused to aggression. However, these young men were from the upper crust of society; they did not need hidden knives and openly carried swords by their sides.

The two men were Captain Thomas Bedingfeld and Thomas Berney. These are well known Norfolk families; the main branch of the Bedingfeld family still live in Oxburgh Hall, while the Berneys have given their name to the Berney Arms inn, windmill and railway station. The men, who were both in their twenties, got into an argument when drinking together in the inn on the night of 19/20 July 1684. The quarrel led to Bedingfeld running out of the inn at two in the morning, chased by Berney, the latter with his sword raised. He caught up with Bedingfeld in the street in Saint Andrews and ran him through with his sword. He died instantly. The wound was in the back, so it was a murder rather than a fair fight between the two men. In those days justice could be extremely swift, especially if, as in this case, the assize judges happened to be in town. If they had not been, Berney would have had to linger in prison until their next visit, six months later. As it was, Berney was tried the following day and just two weeks later, on 8 August 1684, he was hanged. The place chosen for his execution was another of the hanging places in Norwich, the Town Close, then a field just outside Saint Stephen's Gate (it was built over in the nineteenth century). After his death, his body was put into a coffin and sent to his friends to be buried.

The other murder, seventeen years later, was at the other end of society. Robert Watts lived with his wife in the Old Globe inn on Botolph Street. He was very jealous of anyone paying attentions to his pretty young wife. This was played on by associates, and one of his 'friends' went to Mrs Watts and asked to borrow her

11. The Maid's Head Hotel.

wedding ring for a moment, in connection with an argument about its weight. He then showed it to Watts, implying that he had enjoyed his wife's favours. The 'joke' ended in tragedy. Watts was mad with jealousy and anger; he went straight home and beat his young wife to death. He was soon caught and sentenced to death. He was hanged at the doorway of the Globe – probably the last time in Norwich that a criminal was hanged at the actual scene of his crime. The Globe has long since gone, and the car park beside Anglia Square now stands on the spot of this murder and execution.

FATAL FISTICUFFS

Norwich has had a long and proud tradition in the world of boxing, including recent heroes of the sport like Herbie Hide and John Thaxton. The sport has always attracted controversy, and it has had its fatalities, even in its present strictly-regulated state. In earlier centuries informal battles between bare-knuckle fighters might go on for hours and almost anything was allowed. One such fight took place on the open ground beyond Bishop Bridge on 28 October 1822 and landed one of the contestants in court on a charge of murder. He was Robert Grint and he was charged with 'killing and shying' Robert Purdy. The fight was described by Harry Baldwin, a baker, who was present and who very probably had a wager on one of the men to win. Purdy and Grint shook hands before the start, so that it was a proper fight and not a brawl. Baldwin clearly knew his boxing (today he could have been a sports commentator on Radio Five). He said that at first Purdy was having the best of the fight, so Grint altered his tactics: at the beginning of each round, he closed as quickly as possible with Purdy and tried to throw him down. He was successful in this several times. Once, in particular, he threw him to the ground with great force and fell on Purdy's body with his knees. The fight lasted for about an hour. Afterwards Grint, the victor, shook hands with his opponent, and offered him a drink. Another witness also remembered Grint saying, 'Bob, I like you more than ever, you shall have a glass of whatever you please'. Purdy went, or was taken, to the Marquis of Granby public house. Here he fainted and he was carried home. His mother called for a doctor who attended him, but he died two days later. The doctor conducted a post-mortem: the rings of the windpipe and the throat were broken. Grint, charged with murder, said in his defence that the fight was a fair one. The jury found him guilty but the sentence was light. The judge said that as Grint had already been in prison nine months awaiting trial he would just sentence him to a further three months in gaol.

BODY SNATCHING

One crime peculiar to the nineteenth century was body snatching. Surgeons needed dead bodies to practise upon and to learn about the workings of the human body. One source was from the scaffold; dissection was regarded as a punishment beyond mere hanging, as it meant that there was no corpse to be buried. The only criminal in this book to suffer this fate was John Stratford. However, not enough bodies were available from this source for anatomy students to dissect. They were prepared to pay large sums for more bodies and there were people who were prepared to provide them. There were no set fees, of course, but an anatomist might well pay about £10 for an 'average' corpse – a considerable sum in the early nineteenth century, and one for which many people might be willing to take risks. The bodies had to be fresh and not decomposed, so that they would need to be dug up soon after burial, hence the rumours of 'resurrection men' (as body-snatchers were often called) hanging around at funerals. The bodies of the poor were especially vulnerable, as they could not afford the more solid coffins favoured by richer folk. Readers may remember the story of Burke and Hare, who actually hurried the deaths of their victims in order to provide bodies for unscrupulous Edinburgh surgeons. No instances of murder are known in Norwich, but several cases of snatching bodies from churchyards are recorded. The horror that the crime inspired can be seen by a speech given by a prosecutor at Norwich Assizes in 1828: 'Every decent man would accept, that when he had followed the body of his wife or daughter to the silent tomb, "where the wicked cease from troubling and the weary are at rest", their cold clay should there remain till the last trump shall sound, and the graves give up their dead.'

Our story begins with a parcel, brought to the Telegraph Coach Office in Rampant Horse Street on Saturday 15 February 1823. It was a trunk, 28in long, 13in wide and 12in deep. It was enclosed in a wrapper and addressed to Mr J. Robarts, esquire, to be left at the Flower Pot, Bishopgate, London until called for. (Coaches to London from Norwich normally terminated in Bishopgate Street, just

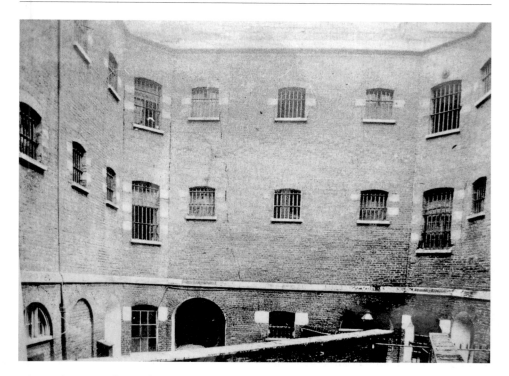

12. Inside Norwich Castle Gaol.

as trains do today; Liverpool Street station is actually on Bishopgate Street.) It was the fourth of its kind to be sent in the previous few days, each weighing between 150lbs and 200lbs, and people at the London end of the Telegraph coach system were becoming suspicious. They suggested that next time such a parcel arrived at the Norwich office, the man bringing it should be detained. This was done and the trunk opened. It contained a human body. In order to fit it into so small a space, the body had been bent double, with the head between the feet, and it was folded so tightly that when it was first opened it was not possible to tell if the naked body was that of a man or a woman. After examination, the body was taken to the workhouse for burial.

Naturally, the parcel-carrier was questioned. He turned out to have no knowledge of the contents of the box (or so he claimed). His name was Ephraim Ulph and he was working for two men who lodged in Saint Michael Coslany parish, Joseph Nichols Collins and Thomas Crowe. Ulph's story was soon told. Some weeks previously, he had asked a man he met in Magdalen Street if he had any work. The man was Crowe, who took Ulph to the Dyers public house and gave him a meal and some drink. He offered Ulph a job looking after his horse,

for which he was to receive bed and board. Collins, Crowe and Ulph soon moved into rooms owned by Mrs Rice in Coslany. Collins began to ask Ulph to take parcels to the coach office. They were very heavy, so Ulph obtained a barrow for the purpose. Collins gave him 6d each time, out of which he gave 2d to the coach office for the booking.

Naturally, Collins and Crowe were arrested and committed to the City Gaol. Their premises were searched and two teeth were found which fitted into the mouth of the body in the box. These had probably not fallen out but been removed deliberately: dentists were prepared to pay well for teeth, to be used in the making of dentures.

The identity of the last body was then discovered. It was disinterred so that it could be viewed by Rev. George Carter of Lakenham. He recognised it as that of an old man called Thomas Brundall, who had lived in Trowse and whom he had visited in his last illness. He had buried him 'last Thursday sennight' in Lakenham churchyard. The grave was re-opened and the lid of the coffin found broken, the shroud torn off and left in the grave, and the body gone. The body snatchers had worked in such a professional manner that it would never have been guessed that the grave had been opened by them. Brundall's body was placed back in the coffin and the grave filled in once more. The other boxes, of course, were never recovered and it does not appear that the identities of the occupants were ever found out.

Inevitably, the case aroused a great deal of interest in the city. One correspondent wrote to the local paper, calling himself, rather grandly 'One who wishes the dead not to be Disturbed'. His suggestion was this, 'When a corpse is interred, fill up the grave in the following manner: put a cease of thorns first, then about nine inches of mould (or earth), then another cease of thorns, and nine inches more mould, and so on until two faggots of rough thorns are expended: when I have no doubt it would take four times as long to get at the body as it would without the thorns.'

Collins and Crowe were not kept in prison: they were bailed to appear at the next Quarter Sessions in April. They attended this court only to find the case moved to the next assizes. The case was finally held in July 1823. The box was produced in court, as were items found at the stable that the men had rented – a shovel, some rope and a hamper, in which the bodies were presumably carried from the churchyard. Some skeleton keys were found in the house, and the police had tried these on seven nearby churches, including Lakenham, and had been able to open five of them.

Mrs Catherine Rice said that Crowe had hired rooms and a stable from her, both in Saint Michael, Coslany. He had put a lock on the stable, no doubt to prevent her seeing what was sometimes stored there: however, he left his room open for cleaning. Crowe had sometimes gone out in the evenings. He had told

13. Inquest on an unknown man, later identified as Thomas Brundall (NRO, NCR 6a/29/11).

Mrs Rice not to wait up for him as he might be back very late, or if he got 'into a gossip' he might not be back at all.

The other witnesses came from Lakenham. Rosamond Cooper said that Brundall was a poor old man who had died in her husband's house in Trowse, and his wife and children survived him. She saw him laid out in his coffin and followed it in funeral procession to Lakenham churchyard on 13 February, where she saw the burial. Brundall's married daughter, Ann Alden, actually saw the coffin being screwed down and, of course, attended the funeral, only to see his body later at the workhouse. Not surprisingly, she was said to be 'deeply affected in her testimony'. The Lakenham sexton, Mr Nichols, had also been at the funeral. A rumour that the body had been stolen had spread in the local community, so Nichols and Carter had looked at the grave on the Sunday after the funeral and neither man thought that it had been disturbed. Afterwards, on receiving a warrant from the magistrates, Nichols had opened the grave.

Bodysnatching was not, in fact, regarded as a very serious crime. It was, in any case, difficult to prosecute, as a dead body did not actually belong to anyone and so taking it was not really considered a theft. This was no doubt why Collins and

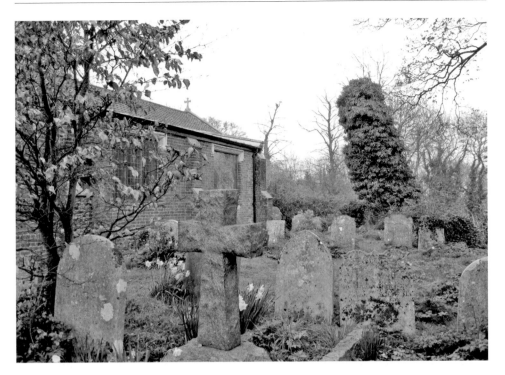

14. The churchyard at Lakenham.

Crowe were careful to leave the shroud, as they could have been charged with theft if they had taken that. The defence counsel rather cheekily tried to present them as benefactors to science, talking of 'The advantage and immense importance it was to science that subjects should be had for anatomizing, by which the structure of the human frame might be better understood'. The jury found both men guilty. They were sentenced to pay a fine of £50 each, and to serve three months in prison.

This was not the only body snatching case in Norwich. The churchyard at Lakenham was especially vulnerable as, although it was not far from the city, it was in the countryside with very few houses close by. The church is now surrounded by council houses, but standing in the churchyard today it is still easy to picture its isolation two centuries ago. Rumours of a further case there were so strong three years later that the church authorities felt the need to put an advertisement in the local press on 2 December 1826:

> Whereas a report was very generally circulated last week, and in a great measure obtained credit, that the body of William Tounshend, which was buried at

Lakenham on Sunday November 19th, had been disinterred and taken away, we, the undersigned, have investigated the matter and certify the following statement to be correct; The relatives of the deceased being much affected at such a report and naturally anxious to ascertain the truth of it, made application to have the grave examined. After due deliberation upon the subject permission was granted for that purpose. The grave was opened on Saturday last in the presence of them, together with us, when it was discovered that the body reposed in its peaceful abode undisturbed. We consider it to be our duty to give this public contradiction to so groundless and scandalous report, in order thereby to satisfy the minds of the parishioners and the public at large. George Carter, vicar; Hunton Jackson, William Norman, churchwardens; Lakenham Vestry, November 26th.

Before 1832, dissection was a feared and hated part of the punishment for murder, as demonstrated in the Stratford case in this book. The 1832 Anatomy Act requisitioned instead the corpses of the poor, transferring the penalty from murder to poverty; anyone dying in the workhouse, with no one to claim their body, was now liable to a fate previously only inflicted on the worst criminals. There were still occasional instances of people selling their own bodies. An extraordinary case of this kind of 'body-snatching' occurred in the city some years later. In July 1838, Mary Maxey complained to the magistrates that her husband's body had been stolen from her house by his former employer, a vet called George Perowne who practised in All Saints' parish. He had died on 8 July. On 12 July, she saw the body at Perowne's and two days later she saw it again, but the body had been hacked about and the heart cut out! Three days later she went with a group of mourners to take the body for burial. Perowne drove them out of his yard with a gun, saying that he had bought Maxey's body sixteen years earlier. It was afterwards taken, without a shroud, into All Saints' church. Perowne was summoned to court on 23 July but he was too drunk to appear! He turned up next day and confirmed that he had indeed bought Maxey's body during his lifetime, and he had cut it up in the interests of science. The magistrates reminded him that as a vet he did not need knowledge of the human anatomy and that his premises were not licensed for anatomical studies. Perowne said that he was a member of Saint Bartholomew's Hospital. He was committed for trial at the assizes. However, the case against him was not proceeded with, and Perowne was formally discharged.

BALLS OF FIRE — RICHARD NOCKOLDS

The case of Richard Nockolds, a thirty-four-year-old Pockthorpe weaver, has several fascinating points. It was one of the last cases where a misdemeanour other than murder, in this case arson, resulted in a death sentence. It shows how closely town and country were intermixed in nineteenth-century Norwich, and the widow exploited her husband's execution in a most unusual way!

The 1830s were a time of protest in both Norwich and Norfolk. In the city, weaving was in decline, and weavers like Nockolds were involved in struggles with employers over jobs and pay. In the countryside, rural protest was prevalent, and the burning of farmers' corn and straw stacks was one form of this unrest. Nockolds was part of a gang of five men who plotted arson at Swanton Abbott, a village twelve miles north of Norwich. The others were Robert Hunt (thirty-four) and three brothers in their twenties, Josiah, David and Robert Davison. The Davison brothers also lived in the city, at Saint Augustine's, only Hunt actually lived in Swanton Abbott. Robert Davison turned king's evidence against the other members of the gang, including his own brothers.

According to Robert Davison, Nockolds was the leader of the gang, and the arson attack was actually planned at Nockolds' house in Pockthorpe. Josiah Davison asked Nockolds if he would come out to Swanton to set fire to the stacks. He said he would give Nockolds 5s, and his brother David would give him 2s 6d. Robert Davison said that David was very badly off and Nockolds replied, 'If so, do not take any from him. I do not do it for money'. Nockolds was clearly experienced at setting fire to stacks. He produced a 'ball' of cotton and lit it, telling Josiah that it would burn for about half an hour – 'it was a piece of cotton wound round with another piece of cotton thread, and a ball part at the end of it, and a tail of about half a yard'.

Robert Davison said that the gang went to Swanton Abbott on 9 January 1831, getting there at about 10.30pm. Aaron Cooke was a key witness: he was coming from the chapel in North Walsham at eleven on that night when he met

40

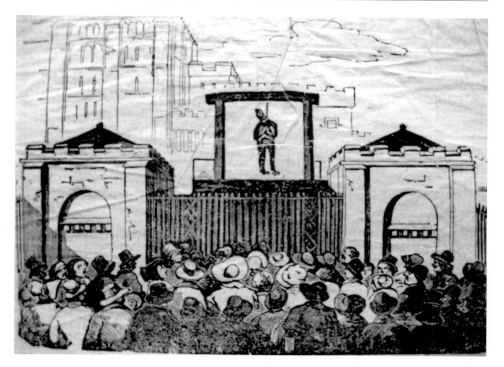

15. Richard Nockold's broadside (NHC).

two men on the road. One was Nockolds, who asked Cooke if he was right for North Walsham. Cooke told him that he was not and said 'I suppose you are after smugglers'. It must have been a strange meeting on that lonely road in the cold and dark January night. Presumably the gang members were on horses – they could hardly have walked all the way from Norwich. Cooke's assumption that they were after smugglers is natural, as the area is only a few miles from a part of the Norfolk coast notorious for smuggling activities at that time. He watched the men as they went towards a farm owned by Richard Ducker. Cooke was sure that Nockolds was the man to whom he spoke. Two notes left on the road that night were later identified as being on paper torn out of a book found in Nockolds' house after he was taken into custody. One note read:

a reward of five hundred pounds will be of no use for I have don it alone. I will surprize you more than this be foure you are one year older. Keep that in mind.

On the outside of the note was written 'The Truth'. After setting fire to stacks on Ducker's Farm, the gang went on to William Blake's farm and repeated the process.

The gang members were tried first for setting fire to the stacks belonging to Blake, Nockolds as the actual arsonist and the other three as accessories. All four men were found not guilty. They were then tried for arson at Ducker's. Nockolds was found guilty and sentenced to death. Josiah Davison was found guilty as an accessory to the fact, sentenced to death but recommended for mercy. Hunt and David Davison were once again acquitted. The sentence on Josiah was in fact respited (postponed), so that Nockolds was the only one of the five to be executed.

According to the local press (but not necessarily to be taken as gospel truth), Nockolds confessed to five other crimes before his execution: he was one of those who shot a man called Springall; one of the gang that attacked Mr Wright and threw vitriol at him, causing him to lose the sight of one eye; one of those who committed a similar attack on a carrier called Green; one of the gang who broke into the house of Mr Warr of Worstead; he was involved in an attack on Mr Maris of Westwick; and he was also involved in urban unrest, being one of the weavers' leaders in the dispute between them and the manufacturers some eighteen months earlier.

Richard Nockolds was publicly hanged outside Norwich Castle on Saturday 9 April. An eyewitness reported that Nockolds 'walked with a light step, and on ascending the platform of the drop, looked round, bowed, and immediately turned his face from the crowd: he stood erect and unmoved while the cap was drawn over his face and the rope attached to his neck.'

Murder cases led to the production of Broadsides, one or two pages describing the murder in the most sensational detail possible, usually with a full confession by the criminal (often invented by the writer), and with several verses pointing out the moral of the case to the reader. One verse of the broadside issued at the time of Nockolds' death ran:

The drop's drawn out, the tolling bell it seems to say, 'Prepare to Die',
I shrink with horror at the sound, but whither can I fly;
Conducted to the fatal tree, my forfeit life to pay,
Ah never in the green gay fields, again with friends will stray.

(The broadside spells the surname as 'Knockolds', and a later hand has added the name as 'Nickolds': variations in surnames like these are a warning to the family historian to be cautious about the spellings that they may come across in their research.)

After the hanging, Nockolds' body was claimed by his family and friends and taken to his cottage opposite the barrack gates in Pockthorpe. It was exhibited

16. Burial record for Nockolds at Saint James Pockthorpe (NRO, ANW BTs).

there each day, the family charging the onlookers one penny each: 'We understand that a considerable sum of money has been raised for the widow from the immense number of persons whose curiosity led them to view the corpse.' Eventually, on Thursday, the body was carried the short distance from the cottage to the church of Saint James Pockthorpe. The corpse was carried by six people and the pall by six others, followed by Nockolds' widow and their four children (the eldest a boy of about fourteen), his mother and father, two brothers and their wives and other relatives, and 'The streets for a considerable distance were literally crowded with persons to witness the funeral'.

The Nockolds case is an unusual one. Arson – almost always haystacks rather than farm buildings – was a common form of protest at this date throughout rural England, but was usually committed by local farm labourers. Nockolds is one of the very few urban dwellers to be charged with the crime. He is also the only one known to have used anything more complex than simple matches to start fires. He is described in a government source as being 'at the head of an extensive body of men who gave him the title of Counsellor'. It seems very possible that he was

regarded by rural labourers as especially wise and knowledgeable. Probably in this case he had no personal knowledge of conditions in Swanton Abbott but was asked to practice his 'craft' there by locals such as Robert Hunt.

It may well be that among the crowds who filed past Richard Nockolds' corpse were many to whom he was not a condemned villain but a local hero, just like Robert Kett three centuries earlier.

DEATH COMES TO PUMP STREET

Many of the crimes described in this book took place in the poorer parts of Norwich. Pump Street, at the top of Rose Lane and almost in the shadow of the Castle Gaol, was one of the worst, with the poor living cheek by jowl in crowded tenements around yards, with totally inadequate sanitation. And, as the name suggests, water had to be fetched from a common pump. It was here that Jane Field's short life ended in violence on 24 April 1851. The character of the area can be shown from the fact that on the very day of her inquest another resident of Pump Street, Thomas Hall, was up before the court charged with attempting to pick the pockets of several ladies at Saturday's Tombland Fair, and he had previous offences of a similar kind to his name. The world of Dickens' London, as described a few years earlier in *Oliver Twist,* was still very much alive in Pump Street, Norwich.

Jane Field cohabited with a man named James Flood in a tenement in Pump Street, sharing just one upstairs room. He was twenty-two years old and their relationship was a stormy one. Flood was abusive and violent, but they had stayed together for at least eighteen months. Finally, though probably by no means for the first time, Flood inflicted serious physical injury upon his 'girl'. One April night, in fact at a quarter to one in the morning, Flood attacked her in Pump Street, just outside their own house. He knocked her down and kicked her as she lay on the ground. She was taken into her neighbour's house and died there on the following evening.

The inquest was held in the local public house, the Eastern Counties tavern in Pump Street. From the evidence, there was no doubt as to the killer. The main witnesses were two watchmen – no doubt they worked in pairs for their own safety – who were stationed at the top of Rose Lane. One, William Skelt, said that he heard cries and saw Jane being knocked down by Flood – they were just 30yds away. He turned his lantern on her (no electric light in the streets in 1851) and saw that she was covered in blood. She was quite senseless. His companion, James

45

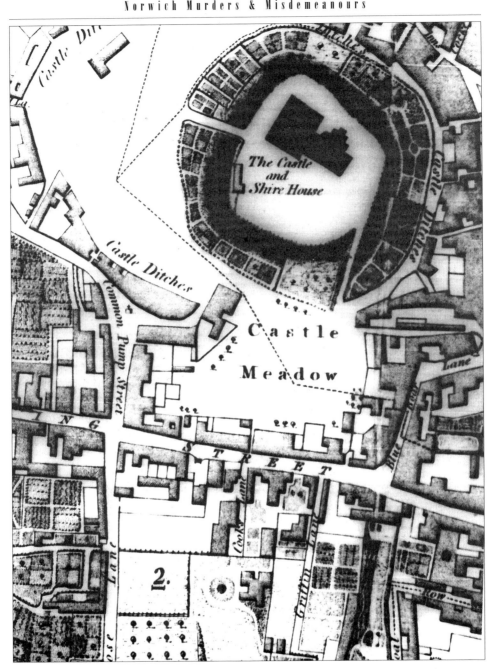

17. *Plan of Norwich showing the castle, Pump Street and the common pump where Jane Field met her death.*

Betts Lefevere, also saw Flood knock Jane down. He said to him, 'What have you done?' Flood was truculent, shouting, 'I will kick her bloody eyes out, and so I will yours'. The two men managed to put their handcuffs onto Flood and marched him to the police station. On the way, he said to Lefevere, 'you think you'll get a bob out of me for this job, but you will not for she dare not appear against me'. Clearly he ruled Jane by fear – the parallel with Bill Sykes and Nancy in *Oliver Twist* is striking – but this time he had gone too far.

Jane Smith lived in the room below the couple. She said that Jane Field came home about 11.30 at night, tipsy, took up Smith's basin and 'cast her stomach', a favourite phrase of this witness. This sobered her up and she said that she was going out. When Smith asked where she was going, she said 'after her sweetheart'. Flood came back at about 12.30 'very tipsy indeed' and went upstairs but could not get into their room – presumably Jane had gone off with the key. He came down in a great anger and said that he was going out and that he would 'knock her eye out and kick her bloody guts in'.

Unfortunately for Jane, he obviously found her before he had calmed down. Smith was just going to bed when she heard cries of 'murder' outside in Pump Street. The police brought Jane in and Smith took care of her although she thought at first that she was only tipsy (a word she seems to use for 'blind drunk' or worse). Jane vomited again, and later brought up almost a basinful of blood. Smith put her to bed and on the next day she was well enough to take two cups of arrowroot, an egg and two cups of tea. She told her friend that she had seen Flood earlier in the evening in London Street. He was (will you be surprised to hear it?) 'casting his stomach' (young people boozing and vomiting in the streets is not a phenomenon just of the twenty-first century). Unfortunately, he spotted Jane and attacked her there, but, after being kicked to the ground, she managed to get away from him.

Later in the evening it was clear to Smith that Jane was dying. Her last words were, 'God bless you, you have been the best of the bunch' – a heart-warming response. Even in this world of squalor, violence and fear, there was at least a little love in the life of Jane Field. Smith tried to play up Jane's character at the trial, claiming that in fact she did not drink that much and was only rarely drunk. However, under cross-examination, she was forced to admit that, 'she was a very aggravating girl, and they often quarrelled'. She died at about twenty to seven on the night after the assault.

Another witness, Caroline Collins, who also lived in Pump Street, saw the attack as well. Flood, who had not said a word to the other witnesses, suddenly became aggressive, asking how she could possibly have seen anything as there was a cart in the way. She replied that she could see over the cart because she was in her

A FULL ACCOUNT OF THE

HORRID

MURDER

...ted by James Flood, on the body of Jane Field, in Common Pum...
...e Castle Ditches, Norwich, on the night of Tuesday the 22nd of Apri...
...t was held at the Eastern Counties Railway Tavern, St. Peter per Mountergate, before Mr. Mendham, on t...

18. 'Horrible Murder' from the Flood broadside (NHC).

bedroom, and also that there was light from the pump (presumably there was a gas lamp there). Another Pump Street resident, George Matthews, saw Flood knocking the girl down actually against the pump, so that the act would have been committed in a relatively light part of the street.

The surgeon was William Day. He had seen Jane in the house, treated her head and put her to bed. He came back five hours later and twice more on the following day. She had eaten, as we have seen, and the surgeon thought that she was recovering. Just half an hour after he left, he was called back to Pump Street. By the time he got there, Jane was dead. He conducted a post mortem on the following day and found that her skull bones were unusually thin and had been fractured at the base of the skull.

Was Jane a victim of the system or had she brought her death upon herself? The law was not on her side, and the charge against Flood was reduced by the magistrates from murder to that of manslaughter. For beating a young girl to death, Flood was sentenced to just eighteen months imprisonment. (Jane's age is nowhere given in the reports of the inquest or the trial, and she could well have been just a teenager.) The broadside about the Flood murder is typical, except that the poem is longer than usual running to thirteen verses. The first two verses set the scene:

Alas! Alas! What woeful tale to you we now relate
Of a poor unhappy young girl that last week met her fate:
She lived within that sink of sin, close by the Castle Dyke
And on the night of Tuesday was heard most bitter shrieks.

The fellow that she lived with his name was James Flood,
A cruel villain he must be that thirsted for her blood:
At a lodging house of ill repute, they lived for years together
And frequent fights and quarrelings they had with each other.

After nine more verses, come the morals to be drawn, first *hers*:

Alas! Young girls take warning by her unhappy fate,
Let no vicious company bring you to this most awful state:
Shun drunkenness above all things for it is the root of evil,
And think of it as nothing but temptation from the Devil.

And, finally, *his*:

And what must be his feelings now in his lonely cell
The anguish of his troubled mind no mortal tongue can tell.
To think that in such a state this young girl's blood was spilt
So never give way to passion, 'tis sure to lead to guilt.

Such a broadside would cost a penny and would make a good souvenir of a public execution, but, as we have seen, there was no hanging in this case, so this broadside probably did not sell as well as many others. The line about the 'sink of sin' is good and sums up the wretched conditions of the Norwich slums, where poverty and crime mixed together. However, the rest of the verses are not up to much, perhaps you could do better? The two main points of a broadside are to be as melodramatic as possible, even at the expense of the truth if necessary, and to finish off with a moral conclusion.

Ten years later, Pump Street itself was gone. In 1861, the houses of this 'notorious locality', as it was described at the time, made way for an extension to the cattle market. This itself has been replaced by a shopping mall, and there is now nothing on the site to bring to mind the dark days of early Victorian Pump Street and the violent death of young Jane Field.

THE PIG LANE CASE —
SUICIDE OR WIFE-MURDER?

On 16 October 1868, Ann Clare was found with her throat cut in the bedroom of the family cottage in Slipper's Yard, off Pig Lane. This runs down to the river behind the Maid's Head hotel, and is now usually spelled Pigg Lane. Her husband, Francis Clare, a forty-two-year-old shoemaker, was arrested. As the Summer Assizes had gone, he was held in prison throughout the winter, finally appearing in court at the Spring Assizes on 27 March 1869. Thus he had plenty of time to consider his defence, which was that Ann had not been murdered at all – she had killed herself. Clare, like many of the Norwich 'murderers' in this book, was a former soldier and he had spent several years in India. In about 1864, he returned to England, settled in Norwich and married Ann Howard. They had had three children, all of whom had died young, and it was said that Clare had been very much affected by their deaths.

Slipper's Yard contained just two cottages. The Clares lived in one, and Ann's father in the other. They were very close, and Mr Howard, who lived on his own, used to come to the Clare's house for all his meals. The rest of the yard was occupied by a carpentry workshop in which three generations of Slippers plied their trade together, but they did not live there.

The facts of the case were not in dispute. The two Clares and Howard had breakfast together as usual. At 12.50pm, Clare was in the Palace Tavern, having a drink of porter with the youngest of the Slippers. At 1.15pm he was seen by three witnesses sitting on a staircase at the opening of the yard. His clothes were covered with blood. Later in the afternoon, at about 4pm, Clare told his neighbours he had found his wife on the bedroom floor and a young Slipper went up with him. Ann was obviously dead: her throat had been cut. On turning the body over, a razor was found in her dress. Had it fallen from her hand or had it been placed there by the murderer to make it look like suicide?

All the witnesses backed up these basic facts. The three witnesses to the staircase scene included two factory girls, Ellen Playford and Rachael Bradfield, who were

19. Pig(g) Lane from the Quayside.

on their lunch break. They worked at Rogers' and Page's factory at the bottom of Pig Lane. The third was a neighbour, Amelia Shimmons, a woman who lived in Pig Lane. She knew the family well and in her evidence made a chance remark

that Ann had a scalded leg; the jury picked up on this later. Howard said that he had last seen his daughter after breakfast, at about 10am, but that he had heard someone (presumably Ann) walking about upstairs at about 11am. He then went to town and did not come back until 5pm. He also suggested that the couple did not get on as well as was generally thought; he believed that his daughter had tried to conceal her husband's ill treatment even from him, her own father.

The crucial evidence was obviously that of the surgeon who had examined Ann's body. This key witness was Joseph Allen. He was confident he knew the answer: 'It would have been impossible for the woman to have inflicted the wounds herself; but it was possible for a man to have inflicted the wounds.'

Of course, he was cross-questioned, the local press gleefully reporting the full gruesome detail of the wounds. He was asked why there would be a difference between the wounds of someone who had been murdered and someone who had committed suicide. He said the differences were in the direction of the wound and in its severity: 'There is generally a difference in both the direction and the depth. If it had been inflicted by herself, I should have expected the cut to have been in a straight line.' The wound was upwards, not in a straight line as it usually was with suicides. Asked if he would pledge his reputation that a person committing suicide would not make such a cut, Allen said that he would not do that, but that he *would* pledge his reputation that a suicide could not cut his (in this case, it should have been her, of course, but he was speaking generally) throat obliquely upward through all the parts of the throat: the woman would have been suffocated by her own tongue and unable to give the final turn to the right that the wound showed.

The prosecutor said that there was no reason why Ann should have killed herself and that Clare had the opportunity: he could easily have done it at about 1pm, when the yard was quiet. He was the only person who would have had the opportunity to commit the murder. No one else could have gone with Ann into the bedroom without causing alarm.

The defence asked the obvious question: would a guilty man have sat on the steps weltering in his victim's blood? He also stressed the arguments in favour of suicide. No screams or cries had been heard, there was no evidence of a struggle, no scratches or torn clothes, and no fragments of hair or clothing in the tightly-clutched fingers of the victim.

The judge summed up. The blood on Clare's clothes showed that he had been near the body, but was this as the murderer? Or did he just turn his wife over to see if there were any signs of life? He raised a new point – why was Ann in her bedroom at all? Surely only of her own choice, or if Clare had somehow lured her there to murder her. However, the foreman of the jury interrupted him to query

this, saying that there was no evidence that they lived in the lower room. The judge squashed this idea – yes, they occupied the whole of the house.

The jury retired for about half an hour. When they came back they had another question to ask. Could Howard assure them that on the day of Ann's death the whole house was occupied, the lower rooms as well as the upper? Howard said that it was and reminded them that all three people had breakfasted in the kitchen that morning. The foreman explained why the jury wanted to know: they had picked up on the statement that Ann had a scalded leg, and this might have explained why she was in the bedroom – her leg pains might have meant that she stayed in bed. The judge praised the jury for the great attention that they had paid to the evidence. They soon came back with their verdict: 'not guilty'. Clare was set free.

Francis Clare was clearly a disturbed man; Howard thought that during his time in India he had suffered twice from sunstroke, although he admitted that he was not sure about this. He had sat on the steps covered in his wife's blood, in full view of several witnesses. He was obviously in shock – was this shock caused by finding his wife dead in their bedroom, or was it because he had just done her to death? What do you think?

VICTORIAN MURDERS — DEATH IN OLD POST OFFICE YARD

The most atmospheric murders are perhaps those occurring in the times of Queen Victoria, such as those of Jack the Ripper in London and the fictional tales of Sherlock Holmes. The city fogs, the few gaslights that illuminated the streets and the limited ability of the police to catch the culprits contribute to the drama of the murder scene. The courtroom itself is a natural scene for melodrama, and whereas today the forensic evidence can seem baffling to a jury, a nineteenth-century murder case depended much more on the jurors' gut instincts as to innocence or guilt, the final act being the black cap donned by the judge to pronounce a sentence of death.

One such murder took place in 1886 in Old Post Office Yard. This is in the very centre of Norwich, just off Bedford Street. It then consisted of just three cottages. They were all owned by Henry Last, who lived in one and rented out the others. He was in his mid sixties at the time of his murder, and, described in the newspapers as 'a quiet old gentleman', he lived alone. The yard was the scene of a surprising amount of wildlife for so central a place, in a way that was characteristic of Victorian Norwich, and Last kept chickens there and had pigeons within his house. He was reputed to be a miser, keeping his cash within his cottage. Such rumours were an obvious temptation to any petty thief.

The murder itself had a prequel some ten years earlier, suggesting that Last was not as peaceful as he was later painted. In August 1876, Last and a man named Elwin Stebbings both appeared at the police court at Norwich Guildhall, each accusing the other of assault on 14 August. Stebbings came first, claiming that Last had stabbed him in the back with a putty knife. The case was dismissed. Last then accused Stebbings of having hit him in the mouth. Stebbings was found guilty and ordered to pay a fine and costs. As he said that he had no money, he was sent to prison for a month.

The next scene in the drama occurred ten years later to the day. On 14 August 1886, a messenger boy, Henry Chilvers, called on Mr Hoydahl, who was the

20. Awaiting execution in Norwich Castle Gaol (NHC).

manager of the Livingstone Temperance Hotel, and a friend of Last's. He told him that Last had not been seen since the morning and that the door to his cottage was swinging open. Hoydahl went round and into the house and saw some sacks on the floor, covering what looked like a pile of old clothes. Lifting the sacks, he saw the dead body of his friend. He summoned the police who established that Last had been dead for some hours, having been struck on the head by three heavy blows from something like a common hammer, and any one of the blows would have been enough to kill him, one even laying bare the brain. Everything in the house was in confusion, as though the killer had turned everything upside down looking for money. However, Last had a safe, which, in fact, had been too much for the thief. Rumours spread about the city that no less than £3,000 in cash had been found in the safe, but, in fact, when opened by the police it was found to contain only a few coins and a post office savings book, showing where Last really kept his money. The rumours of piles of cash in the house had been false, but had probably cost Henry Last his life.

The inquest was held on 16 August and completed a week later after a postponement to allow the jury to view the body. It was held at the Waterman public house in King Street, which had become the usual place for holding them by this date. This was because the city mortuary was just across the road, so the body could be viewed there rather than brought to the pub, as had previously been the case.

21. The entrance to Old Post Office Yard.

Before the second part of the inquest, a man called George Harmer, a twenty-six-year-old plasterer, was arrested in London when he tried to pick up a box of tools he had sent by train under a false name. Harmer was brought back to Norwich and questioned at the magistrate's court at the same time as Last's inquest. Evidence against him was introduced at the latter. The key witness was not named in the press, but actually he was Edmund Nelson, a saw-maker who lived in Lower Westwick Street. Harmer had been imprisoned in Norwich Gaol for a month on 16 July for assaulting his wife. Nelson said that Harmer, who was released on 14 August, came straight round to Nelson's for breakfast. He told Nelson that that his wife had broken up his home and that he was going to kill Last and take his money. He cut himself a piece of board, which he was going to use to distract Last. Nelson's evidence convinced the inquest jurors. Their verdict was 'wilful murder by George Harmer'. Last's body was released for burial at the Earlham cemetery on 25 August.

The trial followed at the assizes court on 22 November 1886. One key witness was Catherine Richmond, who rented the next door cottage from Last. On 14 August, she saw a young man carrying a piece of board go into Last's gate and

past her own cottage. He knocked on Last's door several times and then went away. Last was indeed out and when he came back Catherine told him about his visitor. A little while later, the young man came back, still carrying his board. Twenty minutes later, she heard Last's door slam and someone walk very quickly past her house and out onto School Lane.

The crucial witness was again Nelson. His evidence was damning. Not only had Harmer obtained the piece of board from him, he had told Nelson that he intended to rob Last, using the board as a distraction, and had showed Nelson his hammer, saying that 'I shall hit him with it and daze him'.

The defence naturally queried Nelson's evidence, claiming that he had told different stories at different times, and they even implied he might have been involved in the murder himself. There was no blood on Harmer's hammer or on his clothes. The judge summing up was against Harmer. He said that Harmer had changed his clothes and that there was no reason why Nelson should be telling falsehoods. The trial jury agreed with verdict of the inquest jury. They were out for just five minutes before returning with a verdict of 'guilty'. Harmer received the inevitable death sentence, crying out 'I am not the man. I assure you I leave this dock innocent'. As he was led away, he called out to the public in the gallery 'I am innocent'.

Justice was swift in Victorian England: just three weeks later, on 13 December, Harmer was hanged at Norwich Castle. In fact he was the last person to be hanged there, as the castle ceased to be a prison very soon after. It would be most unfortunate if the last hanging there was that of an innocent man.

The *Norfolk Chronicle* claimed that Harmer was 'supposed' to have confessed to the crime before he died; however, these supposed deathbed confessions in the newspapers are not always to be believed. It went on to say that a hammer had been found in Last's house hidden behind a sink and some tiles, and its head fitted the wounds on Last's head. It was identified as the one in Harmer's possession on the day of the murder. Who made this identification? None other than Edmund Nelson!

THE CITY GAOL

The Roman Catholic cathedral in Norwich is a magnificent building, standing at the highest part of the city, at the junction of the Unthank and Earlham roads. It is in Early English style but is not one of Norwich's ancient churches. It was, in fact, built a century ago at the expense of the then Duke of Norfolk, Henry Fitzalan Howard. He had it built, as he openly acknowledged, as a thanksgiving to God for his happy marriage. It is perhaps ironic that the site on which it was built has seen much unhappiness. As we have seen, it was the site of the Norwich City Prison. It was a place, like Norwich Castle, of hangings in the Victorian period. The two men hanged here, whose stories are told in this book, were clearly both not happily married men, and their unhappy love lives led in both cases to murder.

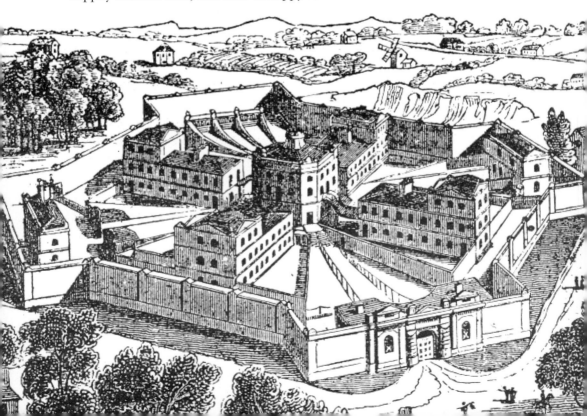

AN ACCIDENTAL POISONER

In August 1829, John Stratford, aged forty-two, was charged with the murder of John Burgess by poison and intending to poison Thomas Briggs, an inmate in Norwich Workhouse. He allegedly mixed some arsenic with flour and caused it to be delivered to Briggs. The flour came into possession of Burgess, who made the flour into a dumpling and died! The case aroused great local interest and the court in the Guildhall had to be especially enlarged for the occasion. As the *Norfolk Chronicle* said: 'The case excites immense interest: the court was crowded to excess from the first of the morning, and numbers were collected outside the doors unable to obtain admittance'. Reporters painted a verbal picture of Stratford: 'he was tall (nearly 6ft in height) and his figure from the knees upwards was athletic and well proportioned. But his legs were unsound: and his feet badly shaped even to deformity. In manners he was decorous and respectful; kind in his behaviour to others; and apparently grateful for all attentions paid him'. The prosecution challenged juror after juror, no doubt trying to weed out anyone who might be an associate or friend of Stratford, and no less than thirteen men were rejected before he was satisfied.

The first witness was Jane Briggs, the wife of Thomas Briggs. She described her situation: 'My husband is ill with a cancer in the face, he has been in the Workhouse since May twelvemonth'. She admitted that she had been put 'in the family way' by Stratford in March – he was a married man and begged her to keep her pregnancy a secret. The two families were close and frequently visited each other's houses. Jane took or sent flour to her husband in the workhouse every week. She often saw her husband taking his meal, 'it was thick milk put into a small tin pot made on purpose'.

Charles Cross, chemist, gave most incriminating evidence. He knew Stratford, who had come into his shop to buy arsenic. It was usual to bring a witness when such a purchase was made and he had brought Thomas Colman. Saying that he needed the arsenic to kill rats, Stratford had purchased 2oz – 2*d* worth. Cross's

Trial and Execution,

23. John Stratford's broadside (NHC).

apprentice served him, putting the arsenic in brown paper and writing 'POISON' upon it. Stratford asked Cross if he had any crude arsenic, and Cross said no, only powdered. He asked if crude was the strongest (Cross said it was). Cross knew both Stratford and Colman well, they lived near him. His apprentice, Dawson, backed up Cross's evidence. Colman was a metalworker and actually used arsenic in his work. The wrapper and arsenic that were found in Stratford's shop were produced and identified.

The next part of the story was told by Susannah Hook, twenty, who had been a servant in the workhouse for the last two years. She had seen Stratford about three times, most recently when he came to the workhouse about three weeks before Burgess died, with a brown paper parcel. He said it was for Mr Briggs. Susannah said she would ask her mistress if Stratford could take it up to him, but he said that she could take it upstairs herself. The parcel was put on the kitchen window. Then Susannah saw Mrs Burgess, who had charge of the sick room, come by the kitchen window and asked her to take it up to Briggs: 'I saw two lines of writing on one side and one on the other'.

Rhoda Burgess was a nurse in the workhouse and looked after Briggs. She received the parcel from Susannah in the kitchen and took it up to Briggs saying, 'here is a parcel for you left in the kitchen'. He took it and felt it to see if it contained money, but it was obvious from its feel that it was flour. Her husband was sitting by their bed, and he opened up the parcel and put it in the cupboard at the front of Briggs' bed. A few days later, her husband took the parcel home to make up the flour. Briggs had said he should do this, as he had no occasion for it himself and did not want the flour to spoil, a kindly deed that was to have dreadful consequences.

On the morning of Monday 2 March, he made the flour into dumplings, using a saucepan on the fire. The local newspaper reports Mrs Burgess's answers to unstated questions, creating a vivid drama, as well as capturing the authentic voice of a poor Norwich woman in the early nineteenth century:

I said, in the name of God what is the saucepan on for, as I have nothing to cook;... I had no flour in the house at that time, or any belonging to my husband; it was the same flour as I received from the Governor's house by the paper; the kitchen is where I live; I knew it by the bag; it was in the pantry in my room; there was nothing but clear water in the saucepan at the time my husband was making up the flour into dumplings; did not see him pour any flour out of the bag; a paper laid close by; appeared to be the same in appearance as the parcel I had put in the cupboard; I had no brown paper in the house that I know of; I had a little flour in the cupboard in a basin; it was taken away with the remainder of the dough; when he went out he went towards Briggs' room with the paper; could not go in any other room on that floor only Briggs' room; saw him finish making the dumplings and bring a couple and put into the saucepan; saw my husband take them out, and took them to the cupboard and cut them up; when they came out there was a dirty white froth on top of the water; after he had cut them up he asked me to have some; I told him no, I thanked him, as I did not like it; seeing my husband eat so heartily of them I thought there was nothing in them; I thought I might be mistaken as jealous something was in them; my husband said, do but come and have some; I took two pieces and gave them to my son; I came up and eat a piece and gave some to what people were there; Mary Morse and Ann Pillar had some after; it was between one and two o'clock after I had eaten it; I felt violently sick; my husband felt so bad he went down to get some beer; before I was sick my child helped him up; in about half an hour he came into my room to his bed; he was helped on the bed he said he was a dying man; he did not say what was the cause; he said his eyesight was leaving him very fast; he was violently sick and reached, but could not get it up; when he said he was dying did not say what was the cause of sickness; I was violently sick and if I had not had great attention should not have recovered; Mr Coleman came first and Mr Robinson directly after.'

John Coleman, the city surgeon, saw Burgess at the workhouse. He was in a dying state, saying he was poisoned and would certainly die. Coleman took away the bag. Later he conducted the post mortem and was convinced that Burgess died from taking a mineral poison. Another surgeon, Mr Dalrymple, opened the body. Burgess had definitely died of acrid poison, probably arsenic.

Mr Stark, a chemist, tested the bag, the flour and the dough. There was arsenic in the dough but not in the flour in the basin (which, it will be recalled, was flour that was already in the house). By brushing the bag with a feather, he got out a few grams of flour to test – they contained arsenic. Later, he analysed the contents of the stomach and found metallic arsenic.

Thomas Briggs was the most dramatic witness. He is described in the newspaper accounts of the trial as 'Briggs the pauper'. He excited both horror and sympathy as he 'had a veil placed over his face, such was its dreadful appearance produced by cancer'. He remembered the parcel of flour coming in February. It was put in the cupboard and he never took it out or saw Burgess do so, he said, 'I mostly lie in bed with my face covered. My own sister and family were the only persons in the habit of coming into my room'.

The case closed. Stratford was told he could now provide a defence. He simply said, 'Oh I am perfectly innocent of the charge; and I declare that I never entered the premises in my life'. Nine people including Rev. R.F. Elwin and William Herring esquire gave the prisoner 'a most excellent character for honesty, humanity and industry'.

The jury debated amongst themselves and, unusually, came back to ask a question about the evidence, They wanted to know whether or not it appeared by the evidence that any flour was taken from the bag before the dumpling was made by Burgess? They were told that there was no evidence. The jury said that in that case they could give their verdict straight away. It was 'guilty'. Stratford's reply was 'I am quite innocent'. He was sentenced to death by hanging and that his body was afterwards to be dissected for science.

He was taken back to prison. It was about midnight and he was given 'some trifling articles of nourishment' in addition to the usual bread and water. On the following day – Sunday – he was more penitent and 'he bitterly lamented the fact of his having been formerly addicted to the reading of infidel publications (Paine's *Age of Reason* was one which he mentioned). He then made a full confession. Later in the afternoon his family came to visit him in prison – his wife, six children, two brothers with their wives and three or four other relatives. 'The youngest daughter, an interesting child, scarcely four years of age, overjoyed to see her "daddy" once again and in blissful ignorance of her family's misfortune, clasped him round the neck, and with infantine simplicity of affection invited him to go home with her "to tea".'

His confession, dated 16 August 1829, contained one surprising fact: the arsenic that was a key point in the prosecution's case was not used at all. According to Stratford, both Cross and Dawson had lied under oath! In fact, he had got a third part of an ounce of crude arsenic from someone for whom he worked (very likely

his friend Colman who had access to arsenic, as mentioned earlier). He powdered it and sifted it through a rag into some flour which he put into the bag. On the night after he had left the flour, his conscience attacked him: 'such terrors seized my mind that I could not sleep'. He would have retrieved the bag the next day but assumed that it would be too late, so he stayed away.

Why had he committed the crime? At the start of his confession he almost implied it was a mercy killing, as, after all, Briggs must have been in tremendous pain: 'She [Jane Briggs] had said to me, what a blessing it would be if God would release him from his sufferings'. However, his basic motive was purely selfish: 'My object was to destroy Briggs, from the fear that the exposure of my intimacy with the woman Briggs (who was pregnant by Stratford) would break the peace between my wife and me'.

Next day – Monday – was execution day. They did not have many hangings at the City Gaol and had to borrow the necessary equipment from the castle: 'The new Drop employed had been, for this time, lent by the County Authorities to those of the City'. It was placed on the flat roof over the lodges of the gaol. He was executed at midday, and the great bell of Saint Peter Mancroft tolled from eleven to the moment of the execution. The *Norfolk Chronicle* reporter was also on the roof, and described the view as Stratford saw it, the last view he was ever to see.

It was a sight still more striking and strange to view from the elevated place of execution the immense concourse of people crowded into a comparatively narrow space in front of the prison, and extending back into Saint Giles' Street as far as it was possible to catch a glimpse of the gallows. The windows and roofs of the neighbouring houses, and even the battlements of Saint Giles' Church Steeple were crowded with spectators; whilst the whole chequered scene of town and country, of prison, field and garden; of so many thousand human faces all eagerly directed towards one poor repentant victim of infidelity and vice, was lighted up by a bright and (rare occurrence this season) an almost cloudless sky.

After the hanging, the body was left suspended for 'the usual time' which was one hour. However, in Stratford's case, this was not the end of the punishment. His body was taken to the Guildhall in Norwich Market Place on a cart. It was placed on the table of the Lower Court and exposed to public view for two hours. Several thousand people came to look and a one-way system had to be introduced: the crowd came in at the middle door of the court and left through the magistrates' door. After this, the body was taken to the Norfolk and Norwich Hospital to be dissected. An Italian sculptor, Mr Mazzotti, took a cast of the head for craniological purposes. It was believed that the size and shape of the head, and any

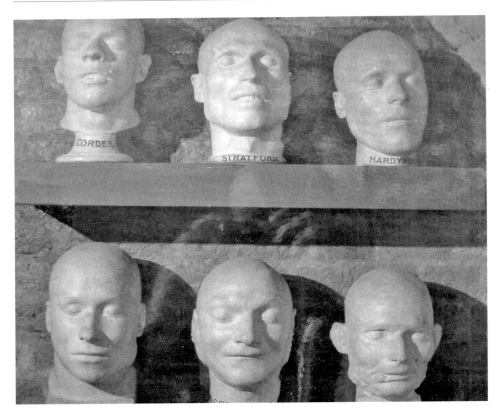

24. Death masks at the castle. Stratford is in the centre of the upper row.

bumps on it, could give information about the criminal propensities of the person. This is why death masks were made of many of those hanged at Norwich Castle. These can still be seen on display there, including that of Stratford himself. The dissection itself began at a public lecture on Tuesday afternoon, just a day after the hanging. The skull was opened and the size of the brain commented upon. The dissection process continued for several days. Although really only for medical men, the hospital took this broadly, admitting not just doctors and surgeons but also 'a great many gentlemen who took an interest in science' – and presumably had a taste for the macabre. Typically for the time, it was tacitly assumed that no women would wish to attend.

John Stratford's early life was described in the press. He was an interesting man. His parents were agricultural labourers in Postwick – indeed his father was still alive at the time of his son's hanging and, aged ninety, was then living in Thorpe. As a child, he tended sheep at South Walsham and at the age of eleven

or twelve he became an apprentice to a blacksmith at Seething. He was keen on self-improvement, earning a little spare money with which he bought a spelling book and some paper. His master would not let him burn candles in the house (even ones that Stratford had paid for himself), so he used to practise writing in the churchyard on moonlit nights, with a tombstone for his table! He became a journeyman at Ludham in 1813 and later moved to Yarmouth where he married. In 1817, the family came to Norwich. He began working for a millwright, Mr Browne, and then worked for Mr Watts, a founder and engineer, for four or five years. Mr Watts owned a steam packet (that is, a steamship) that caught fire. (On the last day of his life, Stratford was asked by the prison chaplain if he had had anything to do with it. He insisted upon his honour, as a man about to die, that far from doing this, he had in fact used all his best efforts to help put out the flames.) He then became landlord of the Swan public house in King Street. At the time of his crime, he was working once more as a smith, this time from his own house in Saint Faith's Lane. There was a garden behind the house and Stratford used to cultivate this with his own hands. He had a reputation as 'a kind and affectionate father'. Then, somehow, Jane Briggs came into his life.

Stratford had confessed the full details as to how he had become involved with Jane, but the local newspaper coyly refused to publish this. Perhaps she had been working as a prostitute. With her husband sick and in the workhouse, she must have been desperate for money. It is an interesting comment on changes of attitude that the newspapers were being coy about sexual matters in the early nineteenth century, but gave full physical details about death and dissection. Would this be true in the twenty-first century or would the reverse be the case? However, the printed broadsides had a field day of vituperation against Jane. She was called 'the infamous woman, Briggs' and one broadside ran 'He [Stratford] supported a wife and six children, till the unfortunate connexion that he formed with this woman, when so infatuated did he become by his animal attachment to this disgrace to her sex, that he sacrificed without remorse, the peace and happiness of his family, to prefer the embraces of this wanton'.

At another Norwich poisoning case, in 1844, a defence was raised that Stratford might have used if he had thought of it. Joseph Paul, forty, was accused of murdering Elizabeth Meek of the Lower Close. Paul was her godson and, according to rumour, actually her illegitimate son. Elizabeth had died at Catton and been buried in Ludham. Suspicion about her death began to grow and in May 1844, she was exhumed and an inquest held. Medical experts decided that there was no evidence of poison and that Elizabeth had probably died of lung disease (she was almost eighty). Paul was already under arrest and, despite this verdict, he was brought to trial at the assizes of August 1844, charged with attempting

to administer arsenic to Elizabeth Meek and to her servants, Elizabeth Webb and William Munday.

Elizabeth Webb gave the crucial evidence. On 19 April, Paul had been in the house, as he very often was. At about 1pm on that day, she had cleaned out the shelves of the meat safe, which had a piece of mutton hanging in it. An hour later, she heard Paul open the safe. After he had left the room, she went to have a look. The mutton was swinging backwards and forwards in the safe, so it had clearly been touched. She could see a white powder had been put into it, between the lean and the fat. There was more of the white powder on the shelf, which had not been there an hour before. She showed the mutton to her fellow-servant Munday and later (after Paul had gone) to her mistress. Munday recalled the incident: a hole had been cut into the meat and a paste-like substance added. The overseer for the close was John Elmer, and he took some of the paste and gave it to Mr Phillippo, who tested it. He thought it *was* arsenic, so he procured the mutton itself. Two surgeons tested it and said that it contained at least twenty grains of arsenic.

The first line of defence was a bold one. Even if the facts were admitted, said Paul's counsel, the prisoner could not be charged with administering or attempting to administer poison. Poison could only be said to be administered when it was actually offered to a person. As the meat was uncooked, it was in no state to be eaten and so the poison could not be said to have been administered at all. The judge thought this through, and said that if the charge had been one of administering poison, the argument would have been perfect. However, the charge was of *attempting* to administer poison. If it could be shown that the arsenic would have lost some of its qualities and character in the cooking, then that would have been an answer to the charge. He recalled the surgeon, who said that some of the poison might have fallen out during roasting, but it would just have gone into the gravy!

The defence then turned to three other arguments. There was no motive for Paul to commit the murder. Even if he was Elizabeth Meek's son, he was illegitimate, so he would not get any financial benefit. The evidence against Paul rested solely on the evidence of the servant, Elizabeth Webb, and she could equally well have added the poison herself or be shielding someone who did. Finally, there was no evidence that Paul had purchased any poison. The cumulative force of these arguments was convincing. 'The Jury consulted for a short time, and returned with a verdict of NOT GUILTY, apparently much to the surprise of almost everyone in court.' Had Joseph Paul got away with murder, or had Elizabeth Webb a guilty secret to hide?

The surprise in court was probably because of Paul's known character as a nasty sort of person. Just a week after his acquittal he was in the police court for a

case arising from his attachment to an underage girl. He rashly brought an action against Richard Webb, who had attacked him and whose household included a Miss Prichard, to whom Paul wrote love letters and lent books. When asked in court if he knew how old the girl was, Paul replied that she was probably about eighteen, 'little and old, like a Scotchman's cow'. In fact she was only fourteen, and the magistrate sympathised with Webb. He said that a more justifiable assault could not have been committed than that by Webb on Paul. The magistrate even regretted that Webb had not sufficient youth and health to have kicked Paul out of Norwich! Paul received just one farthing from Webb and was ordered to pay the costs of the court case.

THE CASE OF WILLIAM SHEWARD — A DRAMA IN THREE ACTS AND AN EPILOGUE

Act One: Gruesome Discoveries

The Norfolk Record Office (where I work) houses over twelve million documents relating to the history of Norwich and Norfolk. They tell thousands of dramatic true stories, including many of those in this book. It is a very new building on the site of Norfolk's County Hall, itself built in the 1960s. One hundred and fifty years ago this was the home of the Martineau family, and the woodland around their house, which still survives on the hill above the Record Office, was to be the scene of the first act of a true tale which held Norwich people in thrall for twenty years, and is by far the most dramatic murder story in Victorian Norwich.

Charles Johnson was a youth of sixteen who lived with his father in Trowse and dealt in wood. On midsummer day, Sunday 21 June 1851, he was walking his dog when the animal found an object in a small plantation in Bracondale, off Martineau Lane, also called Lakenham Lane. It was a human hand. Johnson showed it to his father, who took it into the police station in the city. The boy's imagination obviously ran riot as he then went out with his dog searching for more body parts, eventually finding some pieces of flesh on the Hellesdon Road, about three miles from Martineau Lane.

The next find was by Richard Field, another young man, who lived on Bracondale. He and his friend, Richard Fryer, went on that Sunday afternoon to the house of a Mr Merry, whose garden was against Saint Peter Southgate Church Alley. They found a severed hand in a patch of wood just outside the garden. As Fryer said later, 'it was lying in the long grass and leaves on the border of Mr Merry's garden. It was a left hand. The ring finger was cut off. A person going through Church Alley could throw the hand into the wood where we picked it up.'

The feet were found next. Thomas Dent, also of Trowse Millgate, was walking with his dog along Martineau Lane on Sunday morning, when the dog found a

25. From Martineau Lane, with the Norfolk Record Office in the distance.

human foot in the fence and a piece of bone in the plantation. He took them to the police station. Henry Layton actually lived in the Church Alley already mentioned, and he worked in the Albion Mills, just across King Street. A boy came to him saying that he had found a foot in the grass beside the alley.

Norwich was much smaller then, but growing rapidly, and many areas which were still fields and woods in 1851 were estates of terraced houses twenty years later. It was in these rural areas close to the city that more body parts were found. By now the police were actively looking, helped by ghoulishly-minded citizens and local boys. Police Constable John Flaxman went out on the search, after the hand had been brought in, with two other policemen. Flaxman and his friends found parts of a human breast at Stroulger's Field on the Hellesdon Road.

Meanwhile Police Constable Futter went to Martineau Lane where the first hand had been found. He came across a piece of flesh on the bank facing the lane. Later he searched a field off Hangman's Lane (now the Heigham road). Here he found a piece of flesh about 6in long and 2in wide: 'there was hair upon it the colour of a sovereign – what is called sandy hairy'. James Carter found a piece as large as his two hands on the towing path at the Alder Carr at Trowse Eye, and Robert Leech

26. Saint Peter Southgate church alley.

found yet more pieces of flesh on the Tuesday or Wednesday, some in long grass alongside Saint Augustine's Road and some in a field near Reynolds's Mill. There were several other finds, including some that were accidental: Ambrose Andrews

and two eight-year-old friends were playing in a field near the Green Hills when they found three pieces of flesh, and James Palmer found material in a field he was mowing between the Aylsham and Hellesdon Roads.

John Sales, who lived in Bull Close, had the task of emptying the cockey opposite the 'Old Ladies' Hospital' (as he called it in evidence) more generally known as the Great Hospital. Cockey is a Norwich word for a stream flowing into the main river, originally open but by this date entirely covered over. They were used as sewers and drains (this was some years before proper drainage was introduced to the city). The cockey had grates which anyone could lift to dispose of their rubbish of all kinds. When Sales came to clean it out, he saw it was full of blood, so he called on his father to help. They emptied it out in the presence of a policeman who found it to contain entrails and portions of breast, including one nipple.

The first find had been made by chance on 21 June. With active searching, a great deal had been discovered by 25 June: two feet, two hands, an ankle bone, a leg bone, part of the vertebrae, part of the pelvis and portions of the breasts of a woman. Whose remains were they? The age had to be guessed from the size and condition of the hands and feet. The feet appeared to have been unaccustomed to wear heavy shoes or undertake hard labour, and the fingernails and toenails were trimmed and clean. The woman had died recently – within a week of the discoveries. The police then made an error, and one which may have hindered the search for the killer. They decided that the body was that of a youngish girl. The mayor had handbills put out saying that parts of a young female aged between sixteen and twenty-six had been found and asking people to let the police know if any such female was missing. In Victorian Norwich, as in today's city, there were always several such cases current. Various girls were mentioned, including a Mary Villings, a girl who had been working in a local factory, but these enquiries led nowhere. Meanwhile, friends and relatives of a woman who had just gone missing were becoming worried about her safety, but as she was fifty-four years old they naturally made no connection with the newly-found body parts.

The police should not be blamed for this error, obviously they did not have the sophisticated forensic techniques available to crime-busters in the twenty-first century. They could only go by their experience, and they probably had never before had to deal with feet and hands without a body attached to them; it was unfortunate, from their point of view, that the head was never found.

The inspector of police in Norwich in 1851 was Edward Peck. He recalled how eagerly the people of Norwich joined in the search: 'A great many people brought things in to me at that time – mutton bones and beef bones – which of course were

27. The Tabernacle churchyard. Sheward's house was to the right of the yard.

rejected. There was considerable excitement at that time'. The flesh was preserved in spirits of wine. The remains were buried in a vault under the Guildhall, and there the case rested for almost eighteen years.

Act Two: Confession

On New Year's Day of 1869, at about 10.30 in the morning, a man walked into a police station at Walworth in London. He said to the constable 'I have a charge to make against myself'. Pressed for details, he said it was 'for the murder of my first wife at Norwich', adding after a long pause, 'I have kept it for years but I can keep it no longer'. He told the constable that he had left home with a razor, intending to kill himself. He had gone to Chelsea by steamboat but he was unable to commit the act. He began to sob and spoke only at intervals. He identified himself as William Sheward, and said that he was currently innkeeper at the Key and Castle in Saint Martin at Oak parish in Norwich, but that before he had been a pawnbroker for fourteen or fifteen years. Why Walworth? Sheward was born

there, so it presumably had family associations. Sheward was taken into custody and brought back to Norwich to be tried at the Easter Assizes.

Act Three: The Trial

The trial took place on 2 April 1869. Although it was a city crime and should therefore have been conducted in the Guildhall, it had become customary for city cases to be held at the Shire Hall, along with the county cases. The custom was to swear in the grand jury at the Guildhall and then adjourn to Shire Hall. Sheward, now aged fifty-seven, was charged with murdering his wife Martha on 15 June 1851. He had to be carried into the dock as he was suffering from rheumatism in the ankles. In spite of his confession, he pleaded 'not guilty'.

The couple had married in Greenwich in March 1836, he being the younger by fifteen years (he was twenty-four and she was thirty-nine). Martha was born on 29 March 1797, one of a pair of twin girls. This meant that at the time of the alleged murder he was thirty-nine and she was fifty-four. The prosecution made much out of this difference in age: 'prisoner would then be of an age when all the animal passions are, perhaps, at their zenith; while his wife would be at an age when they had almost probably passed away'. In 1851, they were living on Tabernacle Street, near Bishopgate, a street with a few straggling houses on one side and the high flint wall enclosing the Bishop's Palace on the other. Their house was just 300yds from the cockey grating into which entrails had been put in 1851.

Martha's maiden name was Francis, and, although the couple were married in Greenwich, she and her family had long lived in Norwich. Her twin sister had married William Bunn, a Norwich labourer, but was dead by 1869. Other sisters were also married and living in Norwich: Dorothy Hewitt and Mrs Nunn. Martha was last seen alive on 11 June 1851. After that date, her sisters often met Sheward and asked about Martha, and he always told them that she had run off to a man in London and that he had heard nothing from her. Mrs Nunn once asked him outright, 'What have you done with my sister?' and Sheward replied 'I have not done anything with her – your sister went away and left me penniless'. Mrs Nunn said, 'Sheward, you are a false man, my sister never went away and left the country at all'.

Sheward continued to work for Christie the pawnbroker after the disappearance of his wife. He changed address several times and was soon living with another woman. He rented three rooms in Saint George Colegate at Michaelmas 1851, living there alone at first, according to his landlord. Soon he was joined by two women, one of whom was the lady who later became his second wife, Charlotte

Buck. He was given notice to quit and twelve months later was living in King Street, and he and Charlotte were certainly living as man and wife by Michaelmas 1853. In the 1861 census they are recorded as living in King Street, with two children (they had five children altogether). Charlotte gives her name as Charlotte Sheward and is described on the census return as Sheward's wife, but in fact they were not married at the time of the census, but formally married at Norwich Registry Office on 18 February 1862. He was forty-nine and she was just thirty at the time of their wedding, so he had replaced an older woman with a much younger one. He describes himself on the marriage certificate as a widower and a pawnbroker, and they both give their address as King Street, Saint Peter Parmountergate.

The main body of evidence was naturally that given by the finders of body parts eighteen years earlier. They included the finders of the two hands. Charles Johnson was now thirty-four and described as 'a diminutive fellow'. Field had died in the interim, but Fryer described the finding of the other hand. The police and the drain cleaner also gave their evidence.

The confusion about the age of the woman to whom the parts found in 1851 belonged was brought up at the trial; the body parts had been exhumed when Sheward was brought back to Norwich. One expert witness stated that 'in my judgement the appearance of the flesh and skin was inconsistent with the woman being 54 years of age'. However, it was also said that they could easily be those of a woman in her mid forties, and even that the mayor had gone beyond what the police surgeons had said at the time when he had put out his handbill stating that the victim was no older than twenty-six.

The defence brought forward no witnesses, not even Sheward himself. It consisted solely of the claim that Sheward was suffering from a delusion when he confessed to the murder. The jury retired at 3.05pm. Perhaps surprisingly, they did not come back until 4.20pm, but their verdict of 'guilty' can hardly have come as a surprise. Inevitably, the judge donned the black cap and pronounced sentence of death.

Epilogue: The Execution

After his condemnation, Sheward freely confessed his guilt and gave full details of his crime. The murder was caused ultimately by money. Sheward had amassed considerable savings, and, not trusting his wife, he gave £400 in cash in a box to fellow Norwich pawnbroker, Mr Christie. He gradually spent the money – by June 1851 he had taken about £150 out of his savings. He was clearly in the habit of doing business for Christie, and on 14 June 1851, he went to Yarmouth

on an errand for him, taking £10 in cash to the captain of a ship laden with salt so that he could pay unloading fees. On the following day, he had a row with his wife about his savings and, without thinking, 'ran the razor into her throat. She never spoke thereafter.' He put an apron on her head and went to Yarmouth once more, presumably just to get out of the house. The next day, he went to his work as usual, and on his return he noticed that the corpse was beginning to smell. He began to cut up the body, and to take parts of it around the city, carrying them in a basket. He lit a fire in the bedroom and disposed of what he could in its flames. The head proved difficult; he put it in a saucepan and boiled it over the fire, and then broke it into bits and scattered it about Thorpe. This seems to have worked as the pieces were never recovered. The entrails, as we have seen, he put into a bucket and emptied into the nearby drain. He boiled up the hands and feet hoping they would dissolve: as they did not, he scattered them around Norwich on the Friday night. On the Sunday, he cut up the blankets and dumped them about Norwich, doing the same with the hair. He burnt the sheets, nightgowns, pillowcases and anything else that had blood on it.

Sheward must have been enormously relieved when the police wrongly implied that the remains were those of a much younger woman, as this would have diverted any suspicion that they might have been those of his wife. He claimed that he was not unfaithful to his wife, and he insisted that at the time of the murder he had not met the woman who was later to become his second wife, claiming that he met her on 21 June 1852. Whether true or not, it was obviously in his interest to protect her from being the subject of vicious rumours which might harm her after his death.

The local press described his final night on earth in the City Gaol and his execution in private within the prison walls:

During the night the unhappy man slept well. At half-past one he ate, as he was in the habit of doing, some bread and milk, and again falling into sleep, woke at half-past four. About half-past five he rose, washed and dressed himself, engaged earnestly in prayer, and prepared himself for his fate. He declined to partake of any refreshment. Between six and seven the prison Chaplain, whose ministrations alone the prisoner has received since his conviction, visited the convict and remained with him in religious exercises, until the hour approached for his execution. At a quarter to eight the prison bell and simultaneously the bells of Saint Peter Mancroft and Saint Giles tolled the death strokes.

Sheward was taken to the pinioning room, and because of his rheumatism he had to be carried part of the way. Unsurprisingly his nerve appears to have failed.

28. Norwich Roman Catholic Cathedral (top left) and Saint Giles' church.

'Apparently composed until the pinioning had been completed, the unhappy man then shuddered with a tremor which was visible throughout his entire frame, and which never forsook him until life had ceased.'

At half-past seven there were only a few boys present outside the prison gates, but as the bells rang the crowd swelled to about 2,000. After the hanging, a large black flag was hoisted to show it had taken place. The body was placed in a coffin and buried inside the prison close to the scaffold. Sheward's only memorial was a stone with his initials placed into a nearby wall.

A REMORSEFUL SOLDIER

Sheward was not the only man to confess to a murder in Norwich after years of remorse. In 1851, a soldier called Private Thompson was stationed in Halifax, Nova Scotia, when he went to the authorities to confess to having murdered a girl in Norwich when he was stationed in the city eight years earlier. The crime had preyed on his mind so much that he decided to give himself up and take his punishment. He was brought back to England and the case investigated, with surprising results. He said that when in Norwich he had become intimate with a Norwich girl, Anna Barber, who had been 'in the habit of frequenting the barracks' (readers can draw their own conclusions as to her character from this statement, just as the readers of the contemporary press would have done). They had had an argument one night and he had thrown her into a 'canal'. Either he or the American reporter writing the story down was imperfectly acquainted with Norwich. It has no canal but, of course, does have the river Wensum running through it. Thompson had, in fact, thrown her into the water near Blackfriars Bridge one dark night and had run away from the scene. This was in August 1846.

Now comes the bizarre aspect. That very night, a Norwich tailor (named, most appropriately, James Taylor) happened to be in a boat underneath Blackfriars Bridge, fishing for eels. Out of the darkness he heard 'a scuffle, a shriek, a splash, and the sound of retreating footsteps'. Rowing towards the sounds, he saw someone in the water and hauled this person, a young woman, into his boat and rowed her to safety. She refused to give her name. The date tallied with the confession made by Private Thompson, and indeed Anna had been seen at the Barracks since the supposed murder. Thompson's years of anguish had been for nothing: he had not committed a murder, nor indeed, as Anna had not gone to the police, any other crime.

THE FATEFUL EARRINGS

In several Victorian murder cases, the defence counsel tried to question the morals of the female victim, with varying results. On 21 November 1886 (just one day after Harmer's trial) Arthur Riches, a thirty-six-year-old fish hawker, was charged at the assize court with murdering his wife Matilda in Norwich Haymarket on 8 November. The Riches had lived together for several years, but Riches had become increasingly violent to his wife and she had finally left him. She took a room in lodgings under the name of Mrs Lark, and her landlady's name was Mrs Howard. One day, soon after her move, as she was in the Haymarket, Riches saw her and attacked her. She was rushed to hospital but died on the way. Her throat had been cut but the actual cause of death was suffocation.

There was no doubt that Riches had killed his wife. The questions were whether he intended to do so and whether he had been provoked beyond reason. After his wife had left him he had become remorseful, even venturing to London to try and find her. (It is noticeable how easily people were travelling to and from London in Victorian Norfolk. No doubt they went by train: Parliament insisted that there was at least one cheap train on each railway line.) However, he clearly had a rival in a man named Lark; one witness said that Riches had told him that he would forgive his wife when he found her – unless she was with Lark, in which case he would kill them both. As we have seen, she did call herself Mrs Lark after she had left Riches, so there was presumably some truth behind his fears.

What provoked Riches so much when he saw Matilda? The answer is that she was wearing a brooch and earrings! Clearly he assumed either that Lark had given them to her in return for her favours, or even that she had taken up prostitution, as the defence counsel delicately suggested, appealing to the all-male jury as men of the world: 'what would they have thought under the circumstances?' The prosecution claimed that he took out his knife shouting out 'I will cut your ears off before you shall wear such things' although the witness that he was questioning claimed that these words had not been said. The defence claimed that he took out

the knife intending to cut off her earrings – or perhaps even her ears. However, Matilda struggled and the knife came up against her throat.

The judge was not sympathetic to this line of defence, pointing out there had actually been two attacks. After the assault in the Haymarket, Matilda fled into a yard, probably the one leading to the Lamb inn. Her husband followed her and it was there that her throat had been cut. The jurymen, however, clearly took the man's side. They returned after less than twenty minutes and the foreman tried to say something. The judge said he must just say whether the jury had found Riches guilty or not guilty. He replied 'guilty' but with a strong recommendation to mercy on account of great provocation. The judge sentenced Riches to death, but said that he would see that the recommendation to mercy was passed on to the Queen, for which Riches thanked him. Riches was not hanged. The sentence was commuted to penal servitude for life. In those days, 'life' meant 'life', and Riches died at Parkhurst prison on the Isle of Wight in April 1898. The earrings and brooch turned out to have been lent to Matilda by her landlady to cheer her up – a kindly gesture that was to have fatal consequences!

THE MURDERERS

Another case where the morals of the woman were made part of the defence was also one which has left a lasting impact on the centre of Norwich, and the public house named the Gardeners' Arms has become known as the Murderers ever since, as its pub sign testifies to this day. Frank Miles married Mildred Wilby in Norwich on Whit Monday 1892. Mildred's mother Maria ran the Gardeners' Arms. Miles was formerly in the army and was currently working at Morgan's brewery in King Street, one of the four great breweries of Victorian Norwich (now Wensum Lodge adult education centre). The marriage did not last and at Christmas 1894 Mildred left Miles and moved in with her mother. On the evening of Friday 31 May 1895, Miles went to the Gardeners' and saw Mildred there. He accused her of unfaithfulness, and she taunted him, laughing and clapping her hands. He reacted by throwing an earthen match-holder at her. He went away but next morning he was back at 9am carrying an iron bar, a tool of his brewing trade. He attacked her, severely wounding her in the head. Maria was upstairs when she heard her daughter cry out, 'Mother, Mother, he's murdering me!' Miles left the pub; he went at once to the police station and confessed that he had murdered his wife, handing over the weapon. In fact Mildred was not yet dead. She was found unconscious in a pool of blood. Maria sent her to the hospital where two potentially fatal wounds in her skull were not even noticed – the local newspaper alleged that this was because she was too vain to allow the surgeon to cut off any of her hair to inspect her head. She came home but went to the hospital again on Sunday suffering from pain, and went there once more on Monday. This time she was detained, and she died there during the night.

The case came up before the assizes less than a fortnight later, on 11 June 1895. The defence played up the Friday night incident, claiming that Miles had seen Mildred 'laughing and joking with another man. What did she do but jeer and scoff at him, and be as provoking as possible?' The jury agreed. Miles was found guilty, but they recommended mercy on the grounds of extreme provocation.

29. *The Gardeners, aka the Murderers, Norwich.*

He was sentenced to death but this was commuted to a life sentence. The scene portrayed in today's public house sign bears little resemblance to the true events of 1895.

MURDER IN DENMARK TERRACE

By the end of the nineteenth century, attitudes to the role of a woman as simply 'wife' had begun to change for the better, as reflected in the Sprowston murder case of 14 April 1898. James Watt was forty-four, and had been born in Saint Paul's parish, one of the poorest areas of Victorian Norwich. He was an ex-soldier with twelve years in the Field Artillery, after which he worked as a labourer in Haldinstein's boot and shoe factory. He married Sophia at the Norwich Registry Office in 1876 and the couple had four children, aged three, seven, twelve and eighteen at the time of the murder, but the marriage had descended into physical violence. An Act of 1878 allowed women, for the first time, to obtain a separation from a husband if they had been convicted of aggravated assault upon them. An Act of 1895 then allowed women to decide for themselves on a separation, without the need for a magistrates' order. The magistrate could order the husband to pay a set weekly amount for the maintenance of the wife and any children. Sophia was able to take advantage of these new laws to apply to magistrates for an order of separation on the grounds of violence. This was made on 22 February 1898, and Sophia went to stay with her son James, who was temporarily living in Campling's Yard. At the hearing, James, who was a lance-corporal in the Royal Marines, said that before joining up, he had witnessed seventeen years of cruelty by his father towards his mother. In spite of the magistrates' order, Watt went round to the house with a knife and tried to attack her. For this he was fined 5s or five days in prison, and 'the magistrates took into consideration that the man had been very much knocked about'. During the court proceedings, Watt called out, 'I will do for you; I will do for you if I wait twenty years for it.' As a result, he was bound over to keep the peace for six months. From then on Watt lived with friends in Fishergate, and Sophia and her younger children moved in to the house at 25 Denmark Terrace, which was to be her final home. Watt presumably could not write, or at least only poorly, as he got a friend to write several letters to Sophia on his behalf, pleading for a reunion if only for the sake of the children.

30. Denmark Terrace, Sprowston Road.

On 4 April, Watt bought a revolver at Emms' shop. Five days later, he took it back complaining that it was not working properly and it was mended for him.

The local newspaper presented a pen picture of the murder scene:

> The house which was the scene of the crime is situated nearly at the end of Denmark Terrace, a row of cottages extending along the left side of Sprowston Road from the Prince of Denmark public house. At the rear of the row are a series of small yards, which all communicate with each other and afford access to the back premises. It was in the yard attached to no. 25 of the terrace that the terrible occurrence took place, a small pool of blood almost in the centre of the pathway common to the houses marking the spot where the unfortunate woman's head had rested.

The *Eastern Daily Press* published two versions of Watt's capture, one featuring its sister paper the *Eastern Evening News*. In this version, Mr Syder of the George Hotel, Haymarket, and Mr Smart, an insurance agent of Cardiff Road, were reading about the murder in the paper when they actually saw Watt. This was

Trial & Sentence
Of W. Watt for the
Norwich Murder.

31. The Watt broadside. The lady on the right is not his victim but a London criminal (NHC).

opposite Whitings, in Saint Saviour's Lane, just off Magdalen Street. Watt himself bought a paper from the newsboy, read it eagerly and threw the paper down. He walked into Magdalen Street, accompanied by the pair, who handed him over to a policeman there. At the same moment, one of Watt's sons, aged about thirteen, came up to his father and hit him, saying, 'I'll teach you to murder my mother'. A crowd had gathered by now, which cheered at the boy and hooted at the man.

The second version had Watt walking through Pitt Street, Cherry Lane and Golden Dog Lane, followed by an ever-growing crowd. When he reached Saint Saviour's Lane, they urged Watt to give himself up. Instead he turned into the Hope Brewery and had a drink. The crowd waited outside, and, when he finally left the pub, they followed him into Magdalen Street. Just as he was opposite the Golden Dog Inn, the local policeman appeared, arrested and handcuffed Watt and took him to the police station.

His earlier movements were soon traced. After the shooting, he had hastened up the Sprowston Road, calling in for a drink at the Norfolk and Norwich Arms. When news reached the pub of the murder, he made off, eventually winding up at

his brother's house in Hen and Chicken Yard, where he changed his trousers. Only after that was he seen in the Magdalen Street area.

At the assizes 'there was a large attendance at court, including not a few ladies'. Watt, when asked to plead, said, 'I am guilty of murder but not of wilful murder'. This was entered as a plea of 'not guilty'.

The main witness was Lily Burrows, the wife of a compositor and the next-door neighbour at No. 24. She said that Sophia was hanging out washing in her back yard with her little daughter when Watt showed up at about 2.30 in the afternoon of Thursday 14 April. The girl ran into the house. Watt must have asked why her daughter ran from him as Lily heard Sophia say 'that is perhaps because she is frightened of you'. They talked and she was heard to say, that she 'would not have anything to do with him, she had heard his promises so often'. She went and got a mat and beat it. As she was standing in the back passage, Watt shot her several times, and, as she lay on the floor, banged her head with the gun. He then jumped over the palings and ran off. Sophia died at once. She was found to have in her hand the latest of Watt's letters to her.

Another witness was Mrs Girling of 16 Denmark Terrace who said that after firing three shots Watt put the barrel of the gun into his own mouth. However, if he thought for a moment of committing suicide, he changed his mind and ran away instead. Another neighbour, Mr Drake, a shoe manufacturer, was in his workshop in his back yard. He heard the first shot and looked out, just in time to see Watt fire again. Drake tried to grab him, but he jumped over the hedge and made off with all speed up Constitution Hill.

The defence was led by Ernest Wild, and he clearly had a difficult task as his client had been seen in the act of murder. He tried the old trick of defaming the character of the dead woman, but the judge, Mr Justice Hawkins, was having none of it. Wild tried to make use of a statement by Watt alleging that Sophia had told him she had another lover. The judge interrupted him on several occasions. Once he said, 'You had witness after witness who knew the woman, and there is not one single particle of justification for saying that the woman was a prostitute or had men in the house'. Later, as Wild pursued the same theme, he interrupted again, 'The charge of infidelity against this woman is a pure invention. A man cannot invent a story of immorality on the part of a woman for the purpose of shielding himself from the consequences of a clearly unlawful act.'

Despite the judge's warnings, Wild concluded his defence with a plea for a lenient verdict. 'If the jury believed that the woman told the prisoner that she was expecting another man to see her, he asked them to find that it was manslaughter, and not murder.' The jury were not convinced, in fact they did not even leave the court but gave their verdict at once: 'guilty'.

The prisoner then made a statement, which was not entirely coherent: 'I went to her on the Thursday. My wife's conversation – I had pain on Thursday in my head – could not sleep all night thinking about her. When I went to Denmark Terrace to see her and the children I had no intention of harming her. Murder never was in my heart. But after the conversation with her and harsh words which she addressed to me. I did not know what I was doing at the time.'

The judge sentenced Watt to hang. 'The prisoner was then removed, leaving the dock with a firm step, and looking up at the gallery without showing the slightest emotion.' He was hanged in private at the new prison on Mousehold Heath on 12 July. There is nothing to say that Watt had pangs of guilt, but this is the line taken by the broadside, one verse of which (to be sung to the tune of 'Empty Cradle') reads:

> At night such horrid visions haunt me in my dreams
> I scarce know where to lay my weary head,
> For everything around me so dark and dreary seems,
> I think I see poor Sophie lying dead.
> I can see the cottage plain and think I'm back again,
> With all things bright and happy as of yore
> But alas when I awake my heart's right fit to break
> When I find myself inside a prison door.

Almost fifty years earlier, Flood had beaten his girlfriend to death and gone to prison for just three months. In the early 1890s, Riches and Miles had been sentenced to death for murdering their wives, but their sentences had been commuted to life imprisonment because of defence claims of provocation on the part of the women. In the Sprowston case, a judge had stood up against such imputations and the murderer received his just punishment – the twentieth century had arrived early in the Norwich assize court!

MOTHERS AND BABIES

The only possible case of murder by a woman in this book is the Heigham Railway Street murder, and this reflects the rarity with which women were charged with the crime. The only other time that women appeared in courts on charges of murder were mothers charged with infanticide. These were usually single mothers, very often servants, who were desperate to keep both their positions and their reputations for respectability. In the eighteenth century, such women would be hanged, today they would probably not be prosecuted at all, but be given counselling instead. Victorian cases fall between these two extremes of attitude. Two examples of infanticide from very different classes of society in Norwich in the middle of the 1840s are those of Lucy Thorpe and Sarah Calver.

Lucy Thorpe was a thirty-year-old single mother. In the summer of 1844, she rented a room in the Dove in Saint George Colegate for herself and her son, who was two years old. She appeared to be heavily pregnant and her new landlady, Mrs Roll, asked if this was so. She emphatically denied it. The families got on well together, Emily, Mrs Roll's fifteen-year-old daughter, forming the habit of sleeping in Lucy's bed. One morning in September, Emily came to her mother saying that she had seen a tiny baby under the bed, and had heard it cry at six in the morning. Mrs Roll asked Lucy if there really was a baby under the bed, and Lucy simply said, 'yes'. After her confinement, Lucy got up, dressed herself, put breakfast things on the table and got some water from the pipe presumably intending to feed her son. The baby under the bed was heard to cry and Lucy went to it, drawing a curtain across so that it could not be seen what she was doing (the room had what was described as a tent bedstead). The baby made a gurgling sound and was then silent.

As the death had actually taken place in a public house, the inquest was held downstairs in the same building. There were clear marks on the throat and two doctors agreed that the baby had died from strangulation. The verdict of the inquest jury was 'wilful murder against Lucy Thorpe'. The local press, exhibiting

the typical prurience of the age about matters of birth, refused to publish the details of the inquest evidence, but a broadside very soon made them public.

Lucy would normally have had to wait in prison until the following March or April for the assize judges to come to Norwich. However, in the summer of 1844 there had been a large number of arson cases in Norfolk, so a special winter assizes was held in December, at which Lucy was tried. The evidence revealed some fascinating details about life in early Victorian Norwich. Emily slept with Lucy because she had no bedroom of her own; the pan of water from the pipe was brown in colour, no doubt it come from a well or a pump. When Emily asked Lucy what the gurgling sound was that she had heard, Lucy tried to convince her that it was Mr Roll's pet birds making a noise. Like Last in Old Post Office Yard, Roll kept birds, pigeons or perhaps canaries, a common pet bird in Norwich. When Emily got up at eight on that dramatic morning that she saw the baby, Lucy asked if she would fetch her 'two penny-worth of gin', claiming that she was ill because she had eaten cucumbers the previous night.

Medical evidence was that the child had cried for a short time, but that the wounds *could* have been inflicted during self-delivery. The assize judge clearly sympathised with Lucy, who, the court reporter noted appreciatively, was 'a rather well-looking young woman'. After the doctors had spoken, he asked the jury if there was any need to proceed further. The jury agreed, and they brought in a verdict of 'not guilty'. Lucy was discharged.

There was a similar case in the following year, this time within the confines of a most respectable household – perhaps too respectable for a servant to own up to her 'sin'. Sarah Calver, aged twenty-three, was one of two live-in servants in the house of Rev. Kirby Trimmer on Bishopgate Street. She had been there for almost four years. The household included Trimmer's two unmarried sisters. Sarah may or may not have known that she was pregnant, either way she successfully concealed it from everyone, and even the other servant, Charlotte Rose, who shared a room with her, suspected nothing. On the morning of Wednesday 28 May 1845, one of the sisters, Eliza, saw that Sarah was ill, and she said that she had been in great pain all day. Mary, the other sister, mixed a dose of julep for her. She went to her room, where she stayed until 10am the next day. She then came downstairs and did her work as usual, even waiting at dinner (which would have been at lunchtime). In the early evening, she was found collapsed in a heap at the bottom of the stairs. A doctor was called for, and he came the following morning.

On examining Sarah, he realised at once that she had given birth, and gently asked where the baby was. Sarah produced from her trunk an apron in which was wrapped a newly-born dead baby. He asked if it had been born alive, but she said that it had not. The birth had taken place between one and two o'clock

on the Wednesday. Incredibly, Charlotte, the other servant, had sat with her for about five or ten minutes soon after 2pm – she must have already given birth and concealed the child in her trunk. There were marks on the baby's throat, but these did not necessarily mean strangulation: a woman might have innocently affected the injuries. Sarah was remanded in custody. However, when her case came up, she was charged *not* with infanticide but with the lesser offence of concealing the birth of a child. This crime carried a penalty of up to two years in prison.

At the trial, Sarah spoke for the first time, saying pathetically that she not 'know about anything of the sort, for she had never been with any person in such a situation in her life before'. Eliza supported her, saying that she had never known Sarah to misbehave in any way. The jury, however, found her guilty, and she was sentenced to three months imprisonment.

Both of these women had given birth on their own. In Victorian times, births usually took place at home with the aid of a woman who might call herself a midwife, who had no formal qualifications but had the experience coming from having attended at other births. Even if a doctor was present, he might well be of little use if the birth was a difficult one. These aspects are illustrated in the tragic case of Mary Jane Lovett of Costessey. She was the wife of a carpenter and had already had eight children, each seen into this world by Mary Ann Cannell, who was not a qualified midwife but accustomed to help Costessey women 'in their trouble'. For Mary Jane's ninth child, a local apothecary, Raymond Gaches, was also present. This was in February 1845. The boy was born alive and well, but there were complications and the mother died in agony within half an hour of the birth. She was buried in Costessey churchyard, but later rumours (spread by the midwife?) about what Gaches had done led to an exhumation. The woman's body was found to be badly mutilated, and the inquest verdict was 'manslaughter against Gaches'. Gaches was arrested. He managed to escape from custody only to be later re-arrested on a train in Shoreditch on 29 March.

His trial followed swiftly on 8 April 1845. The prosecutor said that the term 'grossest ignorance' was hardly strong enough to apply to what Gaches had done, and that the public needed protection from such medical incompetence. The damage to poor Mary Jane was described in fullest detail: it appeared that her womb and part of her intestine had been cut out during the delivery. Mary Jane must have died in unbelievable agony. She had begged her husband to send Gaches away, but he was sure the 'doctor' must know best and ignored her desperate pleas.

The defence, however, said that medical people could not be indicted like felons if they happened to make an error of judgement when they were doing everything within their power and skill – if that happened, no one would ever dare to enter

the profession! Gaches had passed the examinations at Apothecaries Hall and so was qualified to act. He might not be as skilful as city surgeons, but 'they could not expect the extremes of skill at Cossey [this is how Costessey is pronounced and how it was spelled in the trial transcript], his client was very well qualified to practice at this place'. The defence continued, 'women are the persons who usually performed these offices, and one of the witnesses examined that day had said she had delivered many women. That was the case with his client – he had some of the ignorance of a female under such circumstances, but still he possessed sufficient skill for usual and ordinary cases.' In other words, had Mary Jane been rich enough, she could have gone into Norwich and paid for medical care of a much higher standard, but as she was poor, she had to take what limited skills could be found locally and cheaply, however unsatisfactory! To be fair to Gaches, the defence did name three women who said they had had children delivered by him and that they would be happy to use his services again.

The judge led the jury by saying that it was not a case of criminal neglect or of the grossest ignorance (the spirit of poor Mary Jane might well have disagreed!) and it was quite clear that it was an error of judgement. If they agreed, they would give a verdict of 'not guilty'. Not surprisingly, they did agree and Gaches was acquitted. It is natural to wonder if many 'Cossey' women used his 'services' again at childbirth after the case, or whether they preferred the unqualified but experienced Mary Ann Cannell!

CHILD CRIME

It has always been realised that there is a certain age below which a person is too young to be responsible for any criminal act, although exactly what this age is remains a hotly disputed matter even today. Norwich has had an unfortunate reputation for cruelty to young criminals, and very many books quote a case in the eighteenth century when a seven-year-old girl was hanged in the city for petty theft. Unfortunately the books never give a date or a name and I have not been able to find it in the archives although there were so many hangings in earlier centuries that not all will even have been properly recorded! I suspect if there is any truth in the story it probably relates to an earlier time and also that the youthfulness of the 'criminal' may well have become exaggerated.

However, people whom we would now regard as no more than children were sometimes sentenced to transportation by the Court of Quarter Sessions. In October 1834, four boys, John Lee (thirteen years old), Robert Hipper (ten), Thomas Tench (nine), and John Bush (also nine) were all charged with theft alongside an older boy named John Bowen, who had run away and was not in court. The crime? Stealing the till box from a shop owned by one Maria Edwards, which, when they got it open, was found to contain four shilling pieces and two sixpenny pieces. Lee, Tench and Bush confessed, Hipper pleaded 'not guilty' as the only evidence against him was that he admitted to having received one shilling of the stolen money. The recorder of the court said that it was not usual to convict on such slight evidence, but the jury convicted him anyway. Despite their ages, all the boys had a good many crimes to their names: Hipper had been in confinement on eight previous charges, Bush on five, Lee on four and Tench on two. The judge said that it was the public duty of the court to remove them from the city for a considerable time. All four boys were sentenced to seven years transportation. Bowen turned up at the next court, in January 1835. He was seventeen and was not charged in connection with the till box case. Instead he faced three charges of stealing spades and shovels from different people. Perhaps surprisingly, he was not transported but sentenced to three months' hard labour.

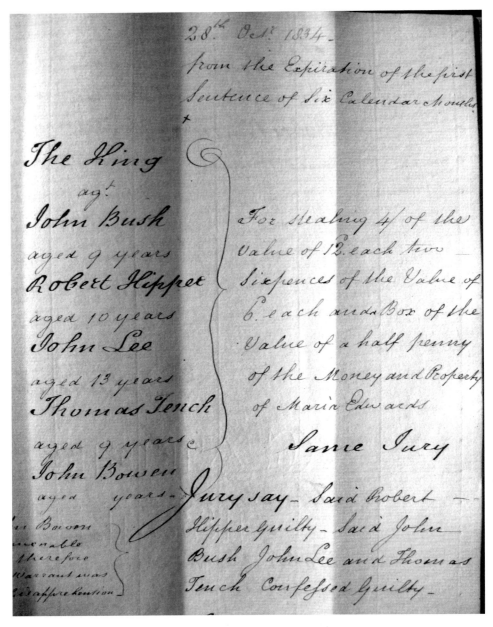

28.th Oct.r 1834 —
from the Expiration of the first
Sentence of Six Calendar months

The King
ag.t
John Bush
aged 9 years
Robert Hippet
aged 10 years
John Lee
aged 13 years
Thomas Tench
aged 9 years &
John Bowen
aged years —

For stealing 4/ of the
Value of 12. each two
Sixpences of the Value of
6. each and a Box of the
Value of a half penny
of the Money and Property
of Maria Edwards

Same Jury

Jury say — Said Robert —
Hippet Guilty — Said John
Bush John Lee and Thomas
Tench Confessed Guilty —

32. *The prosecution of a young gang (NRO, NCR 20/31a).*

In January 1839 William Tuck came before the Norwich magistrates, charged with petty theft. He had stolen two glass bottles, the property of John Culley. This was just one of many dozens of very similar cases, but one fact made it special:

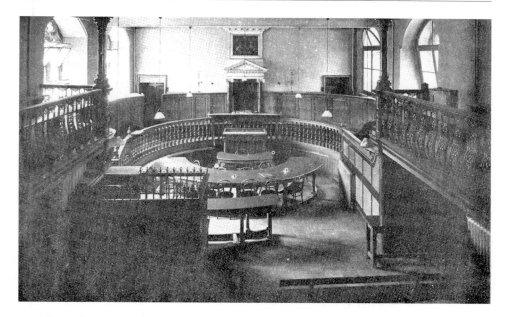

33. The trial room inside the Guildhall.

Tuck was only *eight* years old. In the case of Tuck, the magistrates were apparently harsh, sentencing him to be transported. However, this was really with a view to his being placed in the newly opened penitentiary for juvenile offenders at Parkhurst in the Isle of Wight, an early attempt to prevent young offenders from being corrupted by 'old lags', by setting up a separate establishment for them. The boy had been in custody four times before for theft but had never been charged. He clearly was a victim rather than a criminal. When taken before the magistrates he confessed that he was sent out by his own father to rob and that unless he came home with some stolen property, his father would give him a 'whopping'. A stay in the penitentiary was not instead of transportation, but a preliminary to it, and the experiment was in any case very short lived so Tuck presumably also wound up in Australia eventually.

At another case, in October 1834, it was the mother who was held to blame by the magistrates. Thirteen-year-old Robert Hutchen was an apprentice in the grocer's shop of John Barber. While at work he pilfered quantities of tea, sugar, soap, candles and other articles. His mother, Margaret Hutchen, was also before the court charged with receiving these items, knowing them to have been stolen. The judge was clear that Margaret had failed in her parental duties: 'It was the bounden duty of the mother to have checked the first approach of dishonesty in her son and to have him flogged severely for his conduct, instead of which she

had tutored him to acts of pilfering and had led him in tender years to sacrifice his character for honesty'. In this case, it was the mother who was transported; Robert was sentenced to be whipped and sent to prison for one month. Other 'children' sentenced to transportation by the Norwich Quarter Sessions court in the 1830s and 1840s included Samuel Cone (twelve) in 1834 for stealing a ham, and William Woodcock (eleven) in 1840 for stealing jelly and glasses. No girls of similar age suffered this fate, so either they did not commit such crimes or the court was more lenient to them.

These trials before the magistrates were held in Norwich Guildhall. They must have been dramatic scenes, with some of the children hardly visible above the edge of the dock. It is only natural to speculate as to their future lives. Did they stay in Australia even after they had served their terms of transportation, the Government did not pay for their return to England, of course. Some or all of them may well have remained there – did they make successes of their lives? Perhaps they married and had families – some of their descendants may even be reading this book now!

A CHEATING BANKER — SIR ROBERT JOHN HARVEY HARVEY

Sir Robert Harvey was one of the top men in Victorian Norwich. Born in 1817, he was the eldest son of General Sir Robert John Harvey of Mousehold House, above Lion Wood in Norwich (now apartments). He was High Sheriff of Norfolk in 1863 and represented Thetford in Parliament between 1865 and 1868. He was a banker by profession and a director of the Crown Bank, and their grand building can still be seen at the top of Prince of Wales Road (many people think of it as the Old Post Office, which it became later, after it had ceased to be a bank. The large crown on the pediment is from its time as the Crown Bank, rather than from its time as the Crown Post Office, as many Norwich people think).

In 1870, he was offered the chance of standing for parliament for Norwich, and a petition was got up, signed by over 3,000 Norwich voters, a very large number considering the small size of the electorate of the time. He declined the offer. Probably he was already aware of the disaster that was about to fall upon him and his bank.

Harvey's wealth was shown in his house, Crown Point, still prominent on the hill above Trowse, on which he spent a great deal of money. It was there that, on 15 July 1870, he was seen to walk down to the most beautiful part of the garden about 200yds from the house. Known as the Dell or the Rosary, it was adorned with statues, a grotto and rose bushes. The sound of a shot was heard and servants and friends hurried to the spot. Harvey was found in the garden with a severe wound in his chest. On the morning of the next day, the doors of the bank stayed closed. They never re-opened. A notice was put upon the bank's locked doors:

Norwich Crown Bank. In consequence of the lamentable catastrophe which has happened to Sir Robert Harvey, it has been determined by the other partners to suspend the business of the Bank for the present.

34. Crown Point House, Harvey's home (NRO, BR 35/2/50/4).

The *Norwich Mercury* described the panic in Norwich at the sudden closure of the Crown Bank in terms similar to that of the collapse of the Northern Rock Bank over a century later:

> As might be expected the whole city was appalled. By no other term can the sensation be expressed. The feeling was not one of mere astonishment, but one which could not for a time throw all the impression of unbelief in the possibility of its truth. Yet too true it was found to be by the numbers who went to the Crown Bank in their usual cause of business on Saturday morning and found the doors closed, and all who remained for a time, as if unable, as well as unwilling, to believe in the reality of the printed notices, and of the closed doors before them. There is no need to tell how the numbers, for a time, continued to come and depart; we need not say with what marks of anxiety, or with what depressed hearts at the horror of the accompanying catastrophe. It was too marked to be mistaken, so awful was the event.

However, Harvey was not dead, and he rallied slightly on the following day, only to become worse again two days later. He finally succumbed to his wounds on 19

35. The Crown Bank building, Prince of Wales Road.

July. Meanwhile, the affairs of the bank, which held the savings of a large number of people in Norwich and Norfolk, were rapidly falling apart. Allday Kerrison, one of the partners, signed a declaration of bankruptcy, he and his son, 'gentlemen of unsullied honour, had their fortunes shattered by one dire stroke, through the reckless speculations of their partner, speculations of which they were entirely innocent'. The largest city creditor was George Gedge, and he presented a petition of bankruptcy on the same day, 16 July, while Sir Robert was lying in his bed at Crown Point, desperately wounded.

The inquest on Harvey was held in the breakfast room at Crown Point on 20 July. Charles Elwin, a Norwich iron founder, was at the house at the time of the incident. At about 3.15pm on 15 July, he saw Harvey in the garden. A few moments later he heard a shot. He and several of Harvey's servants ran to the spot. A board was fetched and Harvey was laid on it, in order to carry him into the house. He was in great pain, saying 'My good fellows, walk steady, or I shall be dead before I get there'. He told them to walk on the grass rather than the path, and they had to stop several times because he could not endure the jarring to his body as they stepped forward. He was laid out in the library, an

unfinished room in the new part of the building. A surgeon was called, William Nichols, who was also a friend of the baronet. He saw that Harvey was dying from a wound in his chest and another in his back. Both wounds were small and were caused by a bullet passing right through the body. It was the kind of wound produced by a weapon held close to the person. He was sure it was self-inflicted, whether deliberate or an accident. The surgeon had Harvey removed to his bedroom.

Nichols said that he knew that Harvey had always been very excitable and had lately been subject to great excitement, and especially by news that he had received on the Friday morning, which he believed had caused Harvey to lose his reason. This excitability had begun earlier in the week: Harvey had been to London on the Monday, and on the Tuesday he had appeared to be keen to avoid talking to Nichols. The weapon was found by the coachman, Edward Shield. It had been thrown over the palisading of the rose garden. Shield added that Harvey had been into Norwich on the Friday morning and that he was used to firearms. The jury's verdict was that Harvey's death was caused by firearms discharged by himself whilst in a state of temporary insanity.

Today the Government offers a guarantee to investors that if a bank collapses they will receive at least some of their money back. There was no such security in the nineteenth century, and those with money in the bank must have feared that they had lost it all. Fortunately, another Norwich bank, Messrs Gurney and Co., stepped in and purchased the goodwill and premises of the bank. On the day after Harvey's death, there was a meeting of the principal creditors at the Royal Hotel – not the present hotel almost opposite the Crown Bank but the one in the Market Place, now the entrance to the Royal Arcade. The meeting approved 'the steps taken by Allday Kerrison in suspending the business of the bank, the measures taken to protect the assets of the bank by the immediate filing of a petition in bankruptcy and the negotiations for the sale of the goodwill and the premises to Gurney's'. On 3 August it was reported that the assets of the bank were £910,187 but that the liabilities were far greater at £1,600,321. Over 8,000 Norfolk and Norwich people were owed money by the bank, and protest meetings had to be restricted to the largest creditors, those owed £500 or more.

The cause of the disaster soon emerged. Harvey had been using the bank's money to speculate on his own behalf and had opened false accounts in order to do so. It appeared that he had been doing this since 1860 at the least – that is, he had been getting away with it for ten years or more. The outbreak of the Franco-Prussian War had caused share prices to suddenly collapse. This had ruined him. The total amount that he had lost the bank by his dealings came to £666,000, an enormous sum in the nineteenth century.

Harvey's selfish actions had threatened to ruin many Norwich families, just like the actions of so many bankers before and since. However, he did not retire on a fat pension but took the rap, and he 'did the decent thing', as it would have been expressed in his own time. Crown Point House, the scene of the tragedy, was sold. It later became Whitlingham Hospital, which is the name it is known by to most people in Norwich today.

HORROR IN THE HOSPITAL

The Norfolk and Norwich Hospital features several times in this book. It opened in 1776 and continued in use until very recently: the area is now being redeveloped into a large complex of flats. At five o'clock in the morning of 13 December 1875, there was an attack in the hospital itself that left three children dead and two more severely wounded, and one of these two also died from the attack, after lingering from his wounds for two months.

The dead children, all boys, were: Joseph Colman, from Barton Turf, who had been in the hospital for some time; William Martin, from Ryburgh who had been there for two weeks with a diseased knee; and John Lacey of Grifffin Yard, Pockthorpe, who had been admitted the previous Saturday with pains in his abdomen. Alfred Clarke, of Elm Hill in Norwich, who had been admitted a month earlier, was the boy who died after two months of agony. Edward Lubbock from Buxton, admitted on 4 December with enuresis, was badly hurt in the attack but survived. All the boys were between nine and twelve years old.

The perpetrator of the crime was another patient in the hospital, Robert Edwards. He was in the sixth ward, on the first floor. He had walked down a long corridor, down the stairs and along another long corridor until he came to a small ward on the ground floor in which Joseph, William, John and Alfred were sleeping. Edwards had picked up the fire tongs that were in the grate and went from bed to bed, striking each boy on the head. The nurse was asleep in an adjoining room. Aroused by the noise, she came in as Edwards was attacking Alfred. When the nurse came in, he started to attack her so she retreated into her room and bolted the door. Edwards went on to another small room where three boys were asleep and began his attack with Edward Lubbock. One of the other boys escaped and raised the alarm. The house surgeon, J.R. Baumgartner, came in, seized a poker and attacked Edwards, disabling him, and he was then overpowered by Baumgartner and the hospital porter.

Edwards was taken to the Guildhall at about 11.30am for the preliminary hearing, which was conducted in the Sword Room. Once again, the reporter came

36. Norwich Guildhall.

up with a pen portrait in the absence of any photographs: 'He had a gloomy-looking face, with rather sunken cheeks, and he has a thick but short beard and moustache, with whiskers. He only wore a black cutaway coat over a common white shirt and a pair of corduroy trousers.'

Baumgartner said that Edwards had been admitted on Saturday on the recommendation of a governor of the hospital. Baumgartner had seen him on Saturday night and again on Sunday, when he appeared to be suffering from a nervous disease, 'his manner made me think he was nervous and irritable, but there was nothing to lead me to suppose he was dangerous'. He had seen him again on Sunday evening, when he was lying in bed. The next time he had seen Edwards was early next morning when he was attacking Edward Lubbock. He had been wearing just his shirt and a small red flannel tippett, or cape, which was standard bed-wear for the patients. He had looked at the boys. Lacey was dead, his brains scattered on the pillow, Martin was still breathing but died within an hour, Colman's head was smashed to a pulp. Clarke, the youngest boy (he was nine years old), had a severe fracture to the skull but was still alive.

Dr Bateman said that Edwards came in on the recommendation of Rev. John Gunton of Marsham. He recalled, 'I examined the prisoner and in answer to my questions he informed me that he had been severely ill for about six months, but that his health had not been good for a much longer period. He told me that he suffered considerably from the stomach, that he suffered from flatulence, and pain after meals. He said that for some time he had been obliged to be very particular about his diet, and that he had been obliged to take medicine after each meal as a corrective. I saw nothing in his manner or conversation to lead me to doubt the truth of these statements, and I prescribed for him accordingly.' Edwards had been accompanied by his father and he had not said anything about madness in the patient.

Robert Edwards, aged forty-two, was a weaver and labourer. According to the local press, he had been a 'weakling' all his life. Unmarried, he lived with his parents, described as a 'a poor, respectable but nervous couple', in a small cottage in Crane's Lane, Marsham. He was a quiet man, not a drinker, and was fond of reading the newspapers. Two years previously, he had been off work for about five months, and about four months before the murders he was off work again, suffering from the same complaint – extreme nervousness, depression of the spirits and great pains in the head. His family kept razors and knives out of Edwards' way for fear of his self-harming. Occasionally, he would make strange noises, sometimes similar to the barking of a dog.

One Thursday, just over two weeks before the crime, Edwards had been seized with a violent attack. His father went to an Aylsham surgeon called Martin but he was out, so he called on Mr Little, the parish doctor, who said that he would call round. Little did not come round until Saturday and he ordered Edwards to take more solid food. By the next Thursday he was ill once more and his cousins sat with him all night. Little sent a note to Rev. Gunton, saying that Edwards was suffering from nervousness and that a month in hospital would do him good. Edwards' father doubted if this was the right place for his son but, like so many people, he trusted in the medical experts to know best.

Baumgartner was now defensive. He said that he had spoken to Edwards on Sunday morning when he was coherent and he had said that he had sensations that came over his head, and that he lost control of himself – the surgeon took this to mean that he felt faint. Answering questions from magistrates, he said that 'many patients in the Hospital are suffering from nervous disease without being insane' and that he had seen no reason to have Edwards watched.

Angelina Norcliffe was the nurse in charge of Edwards' ward. At about midnight, Edwards asked for a glass of milk. When she brought it to him, he refused to drink it, but when he thought she was gone, he drank it up. She visited the ward once

more at four in the morning and saw Edwards get out of bed and go towards the fire. On being questioned, he told her that he was cold. She told him to go back to bed and she would fetch an extra blanket.

He went to bed, but when she returned fifteen minutes later he was sitting up. The nurse told him to lie down, and stood over his bed until he complied. While she was in the next ward, a patient named Alfred Page told her that Edwards had gotten up and left the ward; the search for him began.

Nurse Susan Barnes was sleeping in her bedroom next to the boys' wards. She was woken by a banging noise, got up and went into the ward to see a man in his shirt flying from bed to bed, striking the boys with what she thought was a stick. When she opened the door he turned to attack her and she went back to her room and smashed the window to raise the alarm.

Mr Clabburn spoke in Edwards' defence. He said that Edwards himself would say nothing, but that he wanted to produce his father and a surgeon to say that Edwards was not responsible for his actions, and had not been for the last six months. As it was too short notice to arrange this, the examination before the magistrates was postponed until Saturday 18 December. At this hearing, Edwards' father gave evidence that he had had to hide his razors at his son's request, and that on the previous Thursday he had had to have his hands tied and be tied down in his bed. Harriet Edwards and Harriet Skipper, who had sat with him, said that he was raging, barking like a dog and making a hideous noise. Many people in Marsham knew of Edwards' condition and thought he must be sent to the asylum. However, when Little saw Edwards he was calm and it was then that he wrote the fateful letter to Gunton, saying it was a hospital case. Little obviously feared that he would be blamed for what had happened in the hospital and he refused to appear before the magistrates without a subpoena.

Harriet Edwards was a relative. She recalled that on the Thursday, Edwards had kept moaning, 'oh dear me, what is my disease? I have such bad attacks over my head'. Harriet Skipper knew something about mental illness as her own husband was confined in an asylum. She went into the hospital to see Edwards and told the nurse, 'he is a poor, weak, nervous creature: and when those feelings came over his head he lost his mind'. However, she conceded that nothing had been said about Edwards being violent.

Edwards was remanded in prison, to await trial at the next assizes. He was found to be insane and incapable of pleading, and he was sent to Broadmoor Criminal Lunatic Asylum.

THE RAILWAY STREET MURDER

One of the most famous remarks made by Sherlock Holmes comes in the story *Silver Blaze*. When asked by the police inspector about especially significant facts in the case, Holmes draws his attention to the incident of the dog in the night time. The inspector says that the dog did nothing in the night time. 'That,' says Holmes, '*was* the curious incident'. The same point applies with equal force to the murder in Railway Street, Heigham in 1905.

James and Rosa Kowen lived at 29 Railway Street, Heigham. Both aged thirty-eight, they had lived in the house for some years. There were three rooms on the ground floor – front room, living room, washhouse – and two bedrooms. The couple occupied the front bedroom facing the street, their two boys, aged twelve and four, the back room. Kowen worked at nearby City railway station as a foreman cattle porter. He earned 26s a week from this job, but also made money from hiring out carts and horses, and various agricultural activities and deals. He earned extra cash by agisting cattle on the meadows which adjoined the house, that is, providing temporary pasture for the cows en route between the train station and the cattle market.

The night of 29 December 1905 was damp and cold. On that night, Kowen was found dead in the living room of his fire-damaged home. His body was partly burnt and he also had a number of wounds to the head. Rosa was brought in for questioning before magistrates at the Guildhall. She told her story to them. Kowen came home from work late on Thursday evening, when she and their two boys were in bed. Kowen had started to undress but decided to go downstairs and read in front of the fire. She had fallen asleep, and woke up at about half past midnight to a strong smell of burning. She had knocked on the wall of her bedroom and called for help; a neighbour rescued her and the boys through the window.

On Tuesday 2 January, there were two separate 'enquiries': the police enquiry at the Guildhall and the inquest, which was held at the Waterman

public house in King Street. Rosa was at the Guildhall. The local reporter described her as 'a somewhat big woman with sallow complexion and dark hair'. She was formally charged with murder, replying, 'I did not plan to murder him, nor yet to harm him in any way'. Rosa was commanded in custody for a week.

Meanwhile, at the inquest the jurors viewed the body and heard evidence of identification. This was given by Samuel Grand. He, like Kowen, worked at City station, where Kowen had been employed ever since the station had opened twenty-five years earlier. He lived on the opposite side of the street and it was he who had helped rescue the children through the window. Grand said that he had gone into the burning room after the police constable and had helped drag Kowen out, and he was sure that he was already dead. The inquest was then postponed until the following Tuesday to follow the police court action on Monday, but this cosy timetable was upset as the police action was itself postponed, eventually resuming on Tuesday 9 January.

Ethel Tills, who lived next door, came home about midnight with her boyfriend and stood outside with him for some time, and they noticed a light in the Kowens' bedroom. The boyfriend's name was Mark Greenfield. As he was walking away he heard a clock in the city strike midnight, so that fixed the time. When Ethel had said goodnight to her young man and was inside and undressing for bed she heard Rosa call out, 'Fire!' Ethel and her parents went outside and saw Rosa at her window, partially dressed. She was rescued by means of a plank placed at the window by Grand, and the boys were also brought to safety. Alfred Tills went in search of the police and to summon the fire brigade, but a police constable, PC Gardiner, soon came on the scene anyway.

When the constable opened the door from the washhouse to the living room, the heat from the living room was so intense that it singed his eyebrows and scorched his hair, but he was able to notice that there were actually two separate fires in the room: one in the grate, the other in the corner of the room. Great quantities of blood were found on the front of the sofa and on the wall. Kowen was clearly dead. When his body was dragged out of the room, it was at once obvious that it was not the fire that had killed him. He had been beaten about the head. There were two kinds of wound – some made with a sharp instrument but also two blows with a heavy weapon. There was a hammer on the mantelpiece. It had recently been washed but on examination blood was found where the iron joined the wooden handle. A hatchet and a small chopper were found in the coalhouse – and both had blood on them. Traces of paraffin were found under the hearthrug (paraffin was used for lamps and also for

lighting the fire). Paraffin and oil had been purchased on 27 December. The oilcan was found in the kitchen. It was empty. There was a dog in the back yard which would have barked if a stranger had come to the house, and, according to neighbours, it made no sound that night. Greenfield also recalled that the dog made no sound.

One witness was Maria Hastings of Herring Road, West Pottergate Street, who had known the couple for thirteen years and, in the phrase of the time, 'did' for them – that is, did their housework. She claimed she had seen Rosa drunk, and seen her strike four-year-old Clifford on the face with a cane. The couple frequently quarrelled and had been seen to do so about 5.10pm on the evening of the fire. On an earlier occasion when Kowen had accused Rosa of being drunk she had picked up a heavy chair and thrown it at him – it had hit the door and smashed. Kowen had retaliated by using a cane on her arm. This was in November. On another occasion, she was seen with a black eye which she claimed Kowen had given her. Rosa had – according to this witness – several times said she would like to see him brought in stiff and then she 'would have a good drink on it'.

Another witness was Albert Cooper, a fruit-dealer of Barn Road. He had known the couple for seven years and was Kowen's partner in letting out horses and carts. He gave a rather different impression of the couple. He had generally found them on good terms, except once, his last visit on 15 December, when they had quarrelled. Rosa had said – in Kowen's presence – that she would be hung for him, but Cooper had taken this as a joke at the time.

George Edwards gave important evidence. Known to all as 'Yankee' (was he of American origin? The question was never asked), he was a drover who was employed by Kowen to feed the horses. He was paid four shillings a week and his meals, except on Sunday (when the Kowens presumably dined as a family). He slept in a shed on the meadows at the back of the house. He used the axe and the hatchet to chop wood for the Kowens and knew the hammer was kept on the mantelpiece. The last time he had seen Kowen use it was on Christmas Day, when he had broken open a coconut with it! (This cheery story does not chime in well with the atmosphere of distrust and hate implied by some witnesses.) On the night of the fire he saw Kowen at 8.30 pm, went to a pub, came back and went on to his shed on the meadows where he slept undisturbed through the night.

Medical evidence showed that the blows had been inflicted before the burning. One expert thought the fire had been started by spirit or oil burning on the floor. Asked to speak in her defence, Rosa said simply 'I am not guilty'. She was sent to prison to await trial at the next assizes, which took place over two months later.

37. Shire Hall, Norwich.

The trial was held at the Spring Assizes at the Shire Hall on 12 to 14 March 1906. Both sides agreed on a great deal, including that Kowen had been killed in his own living room on the night of 28 December and that the murderer had tried to cover up the crime by making it seem that he had died in a house fire. The one question was this: was the killer his wife Rosa?

The question on which the case turned was this: would the dog have barked if a stranger had come to the house? This was left in dispute between the prosecution and the defence. The dog, it was agreed, was a stock dog rather than a house dog, his main job being to drive sheep from the station.

The prosecution repeated the evidence given at the police court, suggesting that money was part of the motive as, provided she remained a widow, Rosa would receive a pension of £10 a year from Kowen's insurance. The defence rubbished this motive. Kowen earned plenty of money from his horse and cart business and other dealings; at one point a witness had said that Kowen boasted he gave his wife one pound a week so she would hardly have been better off financially if he died. He said that Rosa was not as strong as was implied, and she could, in fact, never have thrown the heavy chair, even if she claimed that she did.

The defence argued the following points: that it would have been very easy for someone to get in from the outside; that the fact that Rosa was fully dressed (it was disputed as to whether or not she was) was actually an argument in favour of

her story, as if she had committed the murder and started the fire she would have made sure she was in her nightdress when she called out 'Fire!'; that Kowen was a dealer and would meet all sorts of rough characters, he was known to carry a lot of cash, sometimes having as much as £20 on him; and that the murderer could easily get away through the meadows and over the railway line. Towards the end of the defence, Rosa burst into tears and 'as she rose and left the dock there were traces of distress in her downcast face'.

The jury went out at 2pm. They were called back at 4.25pm. Asked if they had agreed they said they had not, and asked if there was any chance of their coming to agreement, the foreman said 'I think not, my lord'. The case was therefore postponed until the next assizes. 'The prisoner, standing at the rail of the dock while this momentous announcement was being made, showed no visible sign of intense relief. Her eyes were red, and her face was somewhat flushed, but her whole expression was one of solidity, and it was difficult to obtain any clue to whatever emotions might have been working in her mind.' She was returned to prison, where she was to remain until the assize judges returned to Norwich three months later.

The re-trial, also at the Shire Hall, began on 13 June and lasted for four days. Rosa was described as a dressmaker and as of imperfect education. 'As on the last occasion she was dressed in deep mourning. She appeared to be but little altered in her appearance, but she is by no means so ruddy as she was six months ago. But her face is lined, and there was at first a constant twitching of the left eyelid.'

The defence challenged no less than six of the twelve jurors, who were replaced by other men. The prosecution reiterated that the only question was whether it was Rosa who had murdered Kowen, or whether it was the work of another person. At the end of the first day, the jury went off to look at the house.

The evidence of 'Yankee' was taken at greater length. He said that both the hatchet and the chopper were always kept in the coalhouse. He had last used the hatchet on the afternoon of 28 December and had put it back there. He could not say if the chopper was in the coalhouse then or not. On the night of the fire, he had taken some sheep to Hellesdon, come back into Norwich and gone to the Cardinal's Cap public house until closing time. He had walked back along Barn Road, Heigham Street and Railway Street to the meadow, arriving there about 11.20pm (presumably there was no 'drinking-up' time in those days and he had left the pub at exactly 11pm). He saw a light in the Kowens' bedroom, but he saw no one around and slept in his shed until morning. On going to the house at 8.30am next morning, he found the police in possession. He had seen the couple argue but not seen evidence of blows,

apart from one occasion two or three years ago when Rosa had a black eye which she claimed Kowen had given her.

The prosecution's summary pointed out the difficulties of an intruder committing the murder. The fatal wound had been struck with the small chopper rather than the large axe, suggesting that the crime had been committed by a woman as a man would have used the heavier implement. Would an intruder have washed and replaced the hammer, and put the axes back in the coalhouse?

Ernest Wild was defence counsel, as he had been in the Watt case. He insisted that, although the couple did have arguments, these had been exaggerated. They had just spent a happy enough Christmas together, and Rosa had apparently told Mrs Tills that their relationship was getting better. The defence line was now that Rosa was not dressed when she gave the alarm, being disturbed in her sleep, and this was backed by Mrs Tills. He concluded that the murderer was someone who knew Kowen, who waited outside, slipping in when Kowen went to the closet, attacked him and took any money he had, and then ran out 'through the cattle lairs on to the railway and right away'.

There were three possible views that the jury might take: that the crime was done by the defendant, *without a doubt*; that she *could not* have committed the murder; or that there *was doubt*. As the former jury had disagreed, this jury needed to consider evidence even more carefully than they would have done. Wild spoke for 2¼ hours. As he sat down, 'there was some applause, which was instantly suppressed'.

The judge then summed up on the final day of the trial, Saturday 16 June. His speech does not seem to have been sympathetic to Rosa. If it was true that the axes and hammer were used, any intruder must have known the house extremely well. Why should she think that Kowen had gone out once more so late at night, especially as he had partially undressed before going down? Her statements about this had not been consistent. At first she said that she thought her husband had gone outside at the back (obviously to the toilet, which in those days would have been in the back yard) and then come in again. Later she said she had not heard him return. 'Why did she make these contradictory and conflicting statements? It was for the jury to consider.'

He also raised the question of the victim's blood. This was spattered everywhere in the living room, especially over the walls, and had reached a height of 5ft 10in on the mirror. Obviously, the murderer would have been covered in it. In fact, Rosa did have a few spots of blood on her clothes, which she claimed were there because Clifford had had a nosebleed. However, the judge said she would have had plenty of time to burn blood-spattered clothes; indeed the prosecution claimed that an apron she had been wearing that day could not be located. (Today, forensic

testing would have established whether the blood belonged to the father or the son, but this was not possible a century ago.)

The jury retired at 3.50pm. They consulted for two and a half hours, coming back into court at 6.20pm. Once again they returned to tell the judge that there was no prospect of agreement. Once more Rosa was sent back to Norwich Prison to await a re-trial.

However, the third trial never came. At the beginning of July, it was announced that the attorney-general had decided not to proceed any further with the case. The warrant for her release was received by the prison governor by the first post on Friday 6 July. The local press had wind of what was going on and they 'turned the little strip of roadway that leads to the prison gates into a sentry ground, where hour after hour they maintained a vigilant look out for any sign that point to Mrs Kowen's liberation. In the bar parlour of the little public house that stands within a stone's throw of the prison itself, Mrs Kowen's guilt or innocence was discussed with some degree of warmth. Labourers from the fields in the vicinity driven to seek a few moments retreat from the glaring sun, turned in at the sign of the Windmill, and over their mugs of beer, placed Rosa Kowen for yet a third time upon her trial.'

Norwich Prison had been Rosa's home for six months, but at last her ordeal was over. She was met at the prison by her father and her solicitor. They left by cab, which emerged from the prison gates with drawn blinds, and drove off at a rattling pace to Thorpe Station by Bishop Bridge Road and Riverside Road. All three boarded the 3.27pm train to London and were gone. The children were looked after by family friends, as they had been during her time in prison.

The local paper also had a reporter at Railway Street, who caught the atmosphere well and returned to one of the main characters in the case: 'Railway street at nine yesterday morning was almost as quiet as the gaol at Mousehold. A policeman hovered at the Heigham Street entrance, a rag and bone man picked his way through two little children, too young for school, who were playing on the pavement. Other sign of life there was none.' The house was barred and bolted.

In the yard, in his kennel, lay the dog who has been the subject of so much forensic eloquence, described on the one hand as an animal of the utmost ferocity, who would not let a fly past without barking and biting, described on the other hand as a pretty pet, with whom a baby might play in the interval of taking its bottle. He was quiet enough yesterday, as he lay with his head between his paws, occasionally rising to take a drink from a bucket of water which someone or another, presumably the police, had placed close by.

38. The Windmill. The lane beside it leads to Norwich Prison.

Had Rosa got away with murder? What about 'Yankee' as a suspect – the dog would not have barked if he had entered the house? Or had a stranger indeed waited for Kowen and got away on that dark December night? If you had been on the jury, what would you have decided?

AFTER THE WAR

'Gulf War syndrome' – the supposed harm done to soldiers during a war that prevents them leading a normal life after returning – is a much-discussed phenomenon in the twenty-first century. However, students of history know that there is nothing new under the sun. Soldiers have always found it hard to adapt to home life and this is illustrated well by three Norwich tragedies, all in February 1903, two involving murder, and all involving soldiers who had recently returned from serving with the Norfolk Regiment in the Boer War in South Africa.

The first occurred in the garden of Mr Read of 'Rivington', Newmarket Road (a distinctly upmarket address, as illustrated by the fact that the Read household had a live-in cook). The cook was twenty-four-year-old Ellen Baxter and her boyfriend was James Cook, an ex-soldier living with his mother at Saxmundham in Suffolk and working on the railways. He was a thickset and powerful man of about thirty years of age, who, it was said in the local newspaper, had looked much older by reason of being bald. On the night of Thursday 12 February 1903, the pair were found dead. Cook used to come up to Norwich to see Ellen at weekends. On the previous Saturday, according to the first reports, he had been up as usual, but he had been late in getting back to Saxmundham and had lost his job as a result. To everyone's surprise, he turned up on the Thursday, saying that he had been sacked and asking Ellen's employer if there was any work for him in Norwich. The pair went out at 8pm, Ellen having to be back by 10pm under the terms of her service. Read was having supper with his family and friends, when, at just about 10 o'clock, they heard a noise like a squib outside. They thought little of this and Read went upstairs and began to undress, when two or three more reports were heard outside. Read's son, Jack, and his friends were downstairs still, and they went out into the garden. As they got within a dozen yards of the gate ('Rivington' clearly had a *very* large garden!) they saw two people lying on the ground. At first they suspected a practical joke, but their mood changed when they saw streams of blood coming from the bodies. The bodies were those of a woman, who had been

shot in the back of the head, and a man who had put a bullet in his brain. They were Ellen Baxter and James Cook. An army service revolver was found lying by Cook's side. He had on him a purse with £10 in gold and other cash, a love letter from Ellen and forty-three loaded cartridges.

The inquest was held at the Waterman public house in King Street on Friday 13 February, after the jury had viewed the two bodies in the public mortuary across the road. Cook used to lodge with Mrs Ann Hipper of Melrose Road when he visited Norwich. Ann said that he had first stayed there last September and had stayed four times since. The last visit had ended on 7 February, and she had thought wedding bells were imminent. As he left, he had said, 'Goodbye for the last time'. She had replied, 'the last time before marriage', and he had answered, 'yes'.

Cook's brother was a labourer living in Coldfair Green, near Leiston in Suffolk. He said that Cook would have been twenty-nine on 14 February. He had been in the army and had served in South Africa, arriving back in England on 9 September. While there, he had fallen from his horse, and had had three operations on his injuries. Previously, he had been in India. Cook appears to have been confused about his employment status. Albert Moore, of the Great Eastern Railway, said that Cook had certainly *not* been sacked: 'that was the last thing we should have thought of doing. He was a good workman and we had no fault whatever to find with him'.

The jury's verdict was the obvious one: Ellen had been murdered by Cook, who had committed suicide while of unsound mind.

Just three evenings later, an almost exactly similar tragedy occurred in Norwich. This time, however, the participants were in a lower class of society, the locale a street of terrace houses rather than the garden of a villa, the weapon a razor rather than a revolver and the girl a factory worker.

A man called Davison was returning home to his house in King's Lane when he came across the body of a girl lying in the lane, within a stone's throw of Queen's Road and close to the back of the premises of the Queen's Road Primitive Methodist Chapel. Her throat had been cut. He went to fetch the police – on his way falling over a man who was groaning horribly and also had severe throat wounds. Davison met a policeman on the main road and went on to fetch the police surgeon, Dr Mills, who lived in nearby Surrey Street.

The girl was Edith Fitt, and she was just eighteen years old. She worked at the Albion Mills Confectionary Works on King Street and lived with her parents at 112 Goldwell Road; her father worked on the railway at Thorpe station. Edith was 'walking out' with Alfred Nelson, twenty-three, an ex-soldier – he was identified as the wounded man by a discharge paper in this name being in his pocket.

This inquest was held on 17 February, again at the Waterman on King Street, so that the jury could begin the proceedings by viewing the body in the mortuary (only one this time – Nelson was lying desperately ill in the Norfolk and Norwich Hospital). William Fitt, Edith's father, identified his daughter's body. He had never met Nelson but understood that his daughter was 'keeping company' with him. He did not approve: 'I put my foot down, but I failed to alter it'.

Nelson lived with his mother and stepfather at the Green Man pub in King Street. Fitt had actually gone to this pub on Christmas Eve with his wife and two married daughters. Edith had suddenly turned up, but he did not know whether Nelson was there on that occasion. As so often, the father knew less about his daughter's love life than almost anyone else. He said that he thought they had been going out together for just a few weeks, but the foreman of the jury interrupted to say that he himself had seen them going out together for several months!

Mr Mills, the police surgeon, said he had got to the scene at about 11.15pm. Coming from Queen's Road, he found Nelson first. He was lying on his right side at the corner of a passage leading from King's Lane to Ashby Street, at the King's Lane end of it. He was unconscious, and blanched and cold from loss of blood. About 20yds further along the lane, he saw Edith's body face downwards with her feet pointing towards Queen's Road. Her clothes were not disarranged. He turned her partly and found that she was dead. At about 11.35, the police ambulance came and they took Nelson to the Norfolk and Norwich Hospital.

Next day, Mills examined Edith's body. Her throat had been cut, and the wound could not have been self-inflicted. The wound could have been made by the razor found on the scene. There were old bruises on her left arm and thigh.

The inquest was postponed until 17 March and then to 20 March, by which time Nelson was well enough to appear. 'He is a shortish, stoutly built fellow with a light moustache. He wore a large white muffler about his throat, which served to disguise the dressings which still covered his wounds.'

Henry Vince of the Green Man said that Nelson was his stepson. Vince combined running the pub with a cabinet making business. Nelson had been in South Africa with the Norfolk Regiment and had come back about eleven or twelve months before the tragedy. When Nelson returned after the war, Vince had employed him in his business, but he had been 'on his club' (getting sick pay from his insurance) with influenza for two weeks before the tragedy.

The couple had been keeping company for about six months and had actually come to see him on the last night of Edith's life, coming in together, having tea and leaving together. Nelson said 'shall be back in a few minutes' but did not return. He had had some beer but was not drunk.

Earlier in the evening, the pair had had an adventure, as told to the inquest by Police Constable Carter. His police house was in White Horse Lane, leading from Trowse village to the Caister Road. At 7.45pm, a man knocked on the door. Carter now knew that this man was Nelson, and he had a young woman with him. They told him that they had lost their way in the fields in Trowse. They had come from King Street and wanted to get to the Cock in Lakenham. Carter asked the man if he had been drinking and he replied, 'a glass or two'. The girl was sober and Carter asked her if she would be able to manage him, if Carter showed them the path. She replied that she would, so Carter led them to the footpath across the meadow behind his house that led to Lakenham bridge and to the Cock.

Another witness was Sidney Jones of 8 Ashby Street. He was passing through the passage from Ashby Street to King's Lane at about 10.45pm. He saw Edith, whom he knew, with a man whom he did not know. They were standing close to each other, with their arms round each other's necks and their faces close together. He said that this was the defendant but when pressed he admitted he had not seen the man's face. Later, he saw a man on the police ambulance and was sure *that* man was Nelson.

The inquest verdict was 'wilful murder against Nelson'. Nelson was then tried in the police court in March but chose to reserve his defence; he was committed to be tried at the assizes. This came up on 19 June 1903 and Nelson pleaded 'not guilty'. The evidence was repeated and there was no claim that Nelson had not committed the murder – the question was whether he could be judged responsible for his actions.

The defence concentrated on describing Nelson's mental state and the history of mental illness within the family. Nelson's father was a dipsomaniac and his grandfather an epileptic. Several of his many brothers and sisters had suffered convulsions and two relatives had committed suicide. Nelson was an epileptic and had suffered sunstroke in South Africa. Nelson was found guilty, but the jury strongly recommended him to mercy so that his mind might be enquired into. The judge said he totally agreed with them, and he sentenced Nelson to death in the usual way but issued a strong recommendation for mercy.

The Boer War shared at least one factor with the Gulf Wars of a century later. Although a large number of people supported the war, many others saw it as an unnecessary war, an example of British imperial aggression. Perhaps Cook and Nelson expected to be treated as heroes when they returned to Norwich and came out of the army expecting to rebuild their lives in peacetime. They failed, and their partners were the victims – as were the men themselves. Yet another former soldier was to die at his own hand in the same week in February, but he

did not kill first. This was Private John Stannard, who had also been with the Norfolk Regiment in South Africa. He was of most respectable stock as both of his parents had been head teachers at Norwich Board Schools (his father had died in 1902). On 9 February, he caught a train to Wymondham where he put a single bullet into his temple and died instantly. Clearly his wartime experience was uppermost in his mind as immediately before firing the fatal shot he pinned to the left side of his waistcoat the medal ribbon he had won for service in the South African War.

DEATH ON THE RAILWAY

Great Yarmouth is a popular holiday resort, just twenty miles from Norwich, and it became so in the nineteenth century. Once the railway was built between the two, it was easy to get there and back in a day and thousands of people did so during the summer. There are two lines linking Yarmouth and Norwich, and the one via Berney Arms is the most atmospheric, travelling for several miles through lonely marshes. The occasional heron can be seen, half-derelict windmills along the rivers and sometimes the sails of boats on Breydon Water. It was here that Walter Laws met his death by rifle fire on 23 August 1909, and yet there was no rifle in his train compartment. (In those days, each train compartment was completely separated from the next. Each had its own door, and there was no way to get between compartments during the journey. When I was a schoolboy in South Devon, we used trains like this every day on our way to and from school, and you can imagine the noise if we were able to find a compartment with no adults in it.)

It was August Bank Holiday Monday and the trains were packed. The train in question left Yarmouth for Norwich at 7.05 pm. In the last compartment of the back carriage were eight people, all related. They were Laws, an upholsterer of Peacock Street in Norwich, and his family. Laws was thirty-three, and with him were his wife and their infant of eight or nine months, his mother-in-law, and other relatives, including Arthur and Emily Misson, a Cardiff couple who were related to the Laws, with whom they were staying.

When the train reached Norwich station, one person in the compartment was dead and another badly wounded by a rifle bullet, yet there was no rifle. Between Berney Arms and Reedham, the report of a rifle was heard and a bullet went through the top of the arm of Emily Misson, through the jacket sleeve of her husband who was sitting beside her, and sped across the carriage into the chest of Laws. The communication cord was pulled and the train slid to a halt on the isolated marshes. The only sounds were the cries of the wounded woman.

Just for a moment, a mysterious crime worthy of Sherlock Holmes or Hercule Poirot seemed to have taken place, but it was solved almost immediately. A Norwich policeman, Inspector Gillingwater, happened to be on the train and he went to the carriage and then onto the next compartment where he came across two young men from the Wymondham Company of the 4th Battalion Norfolk Regiment (territorials) who had been on shooting practice at the rifle range in Yarmouth. Their names were William Wade and Melton Brown. They had got a compartment to themselves and put their rifles in the luggage rack. According to the story that they told Gillingwater at the time, one of the lads had picked his rifle off the rack and, not thinking it was loaded, pulled the trigger. The bullet had crashed through the partition, and sped through the next compartment with the result already described: in fact, the bullet went right through Laws' body, entered the partition *behind* Laws and had gone right through that and disappeared.

On Gillingwater's instructions, the train went on to Reedham and then to Norwich with the two wounded people aboard. This would not happen today but in 1909 this was the quickest way to get the victims to hospital. When the train reached Thorpe station, in the city, horse-drawn ambulances were waiting. They took the two wounded to the city hospital (the Norfolk and Norwich). By the time they got there, Laws was dead. Gillingwater had sat in the train compartment with Wade and Brown, during the journey, and at Thorpe station, they were arrested and taken to the police station. The two young men were released on recognisances to appear before the inquest to be held on Wednesday 25 August. Brown was just seventeen years old and Wade only nineteen.

The inquest was held at the hospital. The army authorities said that twenty rounds of ball cartridge were handed out at the range, each man being given five rounds to shoot at each of four targets. Rifles and accoutrements were searched before men left the range: the men had no cartridges on them. The jury viewed the body, and then went to Victoria station to examine the train carriage, just a short distance away on Queen's Road, where Sainsbury's is today. A clean pierced hole could be seen between the two compartments a few inches above the upholstered seats. There was a similar hole behind where Laws had sat. This was the back compartment: the bullet went through the back wall and struck the front of the guard's van, bouncing off it but leaving a mark which could still be seen. Evidence of identity was given by Laws' brother-in-law, a lighterman who lived at Kett's Hill. He had last seen Laws on Sunday night; Laws had gone to Yarmouth on the Monday on business.

Arthur Misson was foreman of a chemical works in Cardiff: he and his wife were staying with Laws, who was his nephew. The group caught the 9.40 morning train from Norwich and met Laws there at 3pm. The Missons were travelling

with their backs to the engine. Misson said that he heard a shot and his wife screamed out 'My arm – I am shot'. Misson saw that his own jacket was torn at the right elbow, and that blood was flowing from his wife's arm. Laws was sitting on the other side of the carriage. Misson saw blood coming from his neck and he called out 'I am shot through; I am dying'. Someone pulled the cord and the train stopped.

Minnie Hare was one of the people in the compartment and the wife of George Hare of Southwell Road. She heard the shot and heard Mrs Misson say 'Oh Arthur, I am shot in the arm'. Laws was sitting opposite Minnie and she too head him cry out, 'I am shot through, I am dying'. It was Minnie who pulled the communication cord and stopped the train. The inspector came up to their compartment, as did a soldier from the compartment in front of them. He said 'What's wrong?' Minnie replied 'Three of my friends are shot' and he retreated back to his compartment.

Gillingwater also gave evidence. He said the train was fourteen carriages long and packed out, impossible to imagine today, when the diesel train on this route is usually just two coaches long and never more than four. It pulled up about a mile after leaving Breydon junction. He got out of the train, saw a young man (whom he now knew to be Wade) standing outside the rear carriage and heard the sound of screaming coming from inside. Gillingwater walked to him and asked him what was the matter. Wade replied, 'a woman has been shot'. Gillingwater tended the two wounded people and ordered the train on to Norwich, where it was met by police, as well as the ambulances.

As the train started, Gillingwater got into the soldiers' compartment and travelled with them to Norwich. He noticed the two rifles lying on the rack, and the conversation went like this:

Gillingwater: How did this happen?
Wade: I did it.
Gillingwater: You must have fired out of the window.
Wade: No, through this [pointing to the hole], that's where I did it.

Gillingwater asked about the spent cartridge. Wade said it must have fallen out when the inspector opened the door of the compartment, but Gillingwater inspected the rifle and found that it contained an empty cartridge. Wade said he had taken the rifle down to clean it: 'I admit I pulled the trigger but I did not know the cartridge was in it'. He said he had fired twenty times at the range, five bullets at each of four targets.

Colour Sergeant Alfred Pritcher, drill sergeant of the Norfolk Regiment, said that Wade and Brown were in his company. Before the firing each man was given

twenty rounds, dealt out in lots of five for each range. At the end of the firing, he examined both rifles, took out the bolts, examined the magazines and chambers, and even looked down the barrels. He asked the men if they had any blank or ball ammunition in their possession and they did not reply, which he took (rather surprisingly, but as it turned out, rightly) to be a negative, as if they did have any, they would have passed it over to him. So he dismissed them. Both men had a good deal of army experience, having attended thirty drills, including twenty for rifle practice. Pritcher admitted that private people also used the range for shooting practice, so that it would have been possible for the men to have picked up stray cartridges.

Wade then confessed. He said that he *had* told the truth to the colour sergeant: he had no live ammunition on him then. However, on the road from the range to the coastguard station he had picked up a live cartridge and put it into his pocket. When he was on the train, sitting with his back to the engine, he had put it in his rifle, thinking of firing it out of the window. He actually pointed the gun out of the window, but changed his mind, and brought it back in. As he did so, it struck the other seat and almost fell from his hand. In grabbing it, he accidentally pulled the trigger and the gun went off. The gun was pointing slightly upwards at the time. The rifle was produced at the inquest, and Wade demonstrated how the accident occurred. He admitted that it took a fairly heavy pull on the trigger to make it go off. He stressed that Brown had nothing whatever to do with the incident. Brown, a solicitor's clerk, was called. He said that Wade had told him that he had picked up a cartridge.

The coroner stressed that he did not think for one moment that Wade had fired intentionally. The jury agreed: their verdict was 'accidental death'.

THE ROSARY ROAD MURDER

Councillor Charles – 'Charlie' – Thompson was a Norwich man and 'one of the best known and most highly respected public men in Norwich'. In 1916 he was fifty-two and managing director of Messrs H. Thompson and Sons Ltd., makers of tin and japanned hardware. Their factory was in Rosary Road adjoining the Norwich City football ground known as 'The Nest' – which would have been locked up at the time as football games were suspended during the First World War. He was married and had two sons, both in the army. Thompson had been city councillor for Thorpe Ward since 1905, and was on the Education Committee and several other committees. He was a prominent member of the Unthank Road Baptist church.

Death came to Charlie Thompson just before nine in the morning on Thursday 20 July 1916. He was walking along the pathway about 100yds from his Chalk Hill Works when a man rushed up to him and stabbed him in the back. Harry Bushell, who kept a shop nearby, ran to the spot. Thompson asked for an ambulance then relapsed into unconsciousness. He was taken to the Norfolk and Norwich Hospital but died a few minutes after arrival.

The attacker ran down Chalk Hill Road into Riverside road, several people shouting 'stop him!' A soldier, Private Thomas Smith of the 46th Provisional Battalion, was walking along Riverside Road. He grabbed the man and held onto him until the police came. The man was William Crosskill, thirty-seven, of 10 Saint Ann's Lane, King Street. According to the local press, 'He was a respectably-dressed man of the artisan class, but gave the appearance of being considerably changed'. The police organised a search for the weapon and found a butcher's knife in Saint Matthew's churchyard almost opposite the spot where the attack took place.

The inquest was held at the Hospital. Charlie's brother, Arthur Thompson, of Hillside, Thorpe Saint Andrew, identified the body. The doctor said that two stab wounds, one in the back and one in the chest, had caused massive loss of

39. Thompson's factory on Rosary Road.

blood leading to death. The preliminary trial was held in the sessions court at the Guildhall on Tuesday 25 July. Crosskill was present and was allowed to ask questions.

We have seen children as victims in the cases of William of Norwich and the hospital murders, and as criminals in the theft cases held in Norwich Guildhall. Here they play key roles as witnesses to the crime. Several children who were on their way to Thorpe Hamlet school had seen the attack, and gave vital evidence. First was Maud Todd, of 27 Marion Road, who was thirteen years old. She went down Hill House Road and to the Rosary Road Co-operative stores at about 8.40. As she left the shop, she saw Thompson (whom she knew), walking with her headmistress, Miss Harcourt. They parted at the bottom of Saint Leonard's Road, with Miss Harcourt going up the hill towards the school, while Thompson went on down Rosary Road towards his factory. When Thompson was opposite the vicarage, Maud noticed that a man was following him, half running and half walking on tiptoe. He caught Thompson and raised his right hand, and she saw that he had a knife. Thompson called out 'Oh!' and fell to the ground. He tried to get up but the man pushed him down again. Then he ran slowly off. When he was between the Co-op and the vicarage gate, he threw the knife into the churchyard. She saw him turn right down Saint Matthew's Road, and lost sight of him as he ran down the hill. She went to Thompson and saw blood trickling down his clothes. Other people very soon gathered, and she stayed until an ambulance

arrived and took him away. She noticed that the knife had a black handle and a pointed blade. Questioned, she said that the man ran away 'at a trot'.

An eleven-year-old schoolboy, Arthur Burton of 41 Rosary Road, gave a clear account of the events – and of his part in them. He was walking on Rosary Road on his way to school. He saw Thompson and Miss Harcourt; Thompson was carrying his coat on his arm. He knew Thompson as he had often seen him at school. When Thompson was passing 63 Rosary Road, he saw the accused come out of the gateway of Saint Matthew's vicarage which was opposite, and walk across the road onto the footpath behind Thompson. When Thompson was opposite the gateway of 57 Rosary Road, the man raised his hand and struck him. The man struck him again when he was on the ground and picked up Thompson's coat and threw it at him. Burton saw the man throw something into the churchyard. He followed the man down Saint Matthew's Road and down the passage at the side of the Co-op. He saw him run down into the lane between the back ways of Saint Matthew's and Chalk Hill Roads, pass the bottom of the latter road along Riverside Road towards Thorpe station. Still following, he saw the man run towards Foundry Bridge, past the 'Doris' landing stage. He saw the soldier stop him.

Two girls, who had been walking together to the school, were rather less clear in their evidence. They were Elsie Spooner, fourteen and a half, of 29 Rosary Road, and Dorothy Meek, thirteen, of Spitalfields. Elsie saw the attack, but when the accused was pointed out in court said 'he is not the man I picked out. The man is not here now'. She had been at an identity parade at the police station and had picked out another man! Crosskill had then stepped forward and said to her 'It was me' – a most co-operative criminal. Dorothy, however, did *think* that the accused was the man.

Harry Bushell was in his shop at 55 Rosary Road when he saw Thompson staggering on the pavement. He ran out to help. Asked by Thompson to fetch an ambulance, he went to Chalk Hill Works and asked the foreman to telephone for the police ambulance. (it needs to be remembered that there were no mobile telephones in 1916 and not many landline phones, so very probably he did not have a phone in his shop.)

Private Smith said that he was standing at the corner of Riverside Road and Foundry Bridge when he saw the accused running towards him, with a crowd following. He caught hold of the man, who said, 'For God's sake let me go. Don't pay any regard to them, they want to get me into trouble'. He then leant on the wall by the bridge and began to cry. The police arrived and took him away.

William Spinks was the foreman at Chalk Hill Works. He said that Crosskill had been employed there as a sheet metal worker from January 1913. In November

40. Bishop Bridge where Crosskill was captured.

1915, he was given a week's notice for neglecting his work and losing time. On his last day at work, he threw a heavy die at the office, hitting the woodwork below the window. He was escorted off the premises, came back next day for his wages, and had not been seen at the Works since.

Herbert Rayner, a work colleague, said that Crosskill had received an injury to his head when a car had knocked him off his bicycle. He had been to see Crosskill at his home in Saint Ann's Lane in July. Crosskill had told him that he had applied for exemption for military service, but had just heard that he had been attested and placed in class C. Clearly, this was a great blow to him, and he might well have thought that Thompson, as his former employer, had played a part.

George Crosskill, the accused's brother, said he had last seen Crosskill about three weeks to a month ago – he was then working for Haldinstein's boot and shoe company. His brother had seen Thompson at Haldinstein's and wrongly thought that he was out to get him sacked from this post as well. He said that his brother had been depressed for a very long time, and that wherever he worked, he always thought his fellow-workers were plotting against him. He began to say that their mother had been in an asylum, but the judge said that this was not material to the case.

Police Constable Plummer had found the knife in some shrubbery in front of a large tree in the churchyard. He took it to Crosskill's house, where Crosskill's wife said that it belonged to them; it had been kept in a box in a cupboard, so she had not noticed that it was gone.

Arthur Thompson said that his late brother had been worried about Crosskill. He read out a letter the accused had written, which was largely incoherent, but was taken by Charles Thompson as thanking him for advice and help; he was thinking of giving Crosskill another chance at the Works.

The verdict of the inquest jury was 'murder'. Crosskill was returned to prison to await trial at the assizes. Meanwhile, there had been a memorial service for Thompson at the Unthank Road Baptist church on the Sunday after his death, followed by the funeral on Monday, attended by the mayor, the sheriff and almost all the city council. Thompson was buried in the Earlham Road cemetery.

It was later confirmed that Crosskill made a voluntary confession to the acting governor of Norwich Prison. The trial was held at the assizes on 19 October 1916. Three months in prison had clearly led to a decline in the state of Crosskill's mental health. He was in a very excited state in the courtroom, covering his face with his coat, and muttering disjointed phrases. A jury was sworn in to enquire if he was fit to plead. A medical expert was asked, 'At the present moment, do you think he understands what is going on?' He replied, 'No, he has no coherent idea of what is going on'. This sounds like a clear enough answer, but the judge was not happy with it, saying crossly, 'why can't you say "yes" or "no", without introducing this incoherent thing'. The question was put once again to the expert, and this time he replied that he did not think the prisoner understood what was going on, and he was in no condition to instruct counsel or object to jurors.

Crosskill then intervened himself, saying, 'I WANT to be tried. Act as soon as you can. If you all act I'll prove it at the finish. I am the living Christ, I must sacrifice the nation. Father protect me. I must not show my face.' The judge said that surely the jury could not have any doubt, and they agreed that Crosskill was not in a state to plead. He was ordered to be kept in custody at His Majesty's pleasure. Still muttering, 'I am the living Christ', he was led back to prison to start a lifetime in mental institutions.

Some of the sites of the crimes described in this book remain much as they were at the time, but others have changed beyond recognition. The prison quarters in Norwich Castle and the Bridewell and the courtrooms at the Shire Hall and the Guildhall are all open to the public. The Roman Catholic Cathedral stands on the site of the City Gaol, but the prison on Mousehold still serves the purpose for which it was constructed a century ago.

This book has looked at murders and misdemeanours in the city of Norwich over more than eight centuries. One of the lessons I have learned from a lifetime of teaching history is that the nature of men and women never changes. Their environment alters, but people remain the same. Doctor Watson in a Sherlock Holmes story sums it up, describing man as 'a soul concealed in an animal'.

Also available from Amberley Publishing

Yarmouth & Gorleston Through Time
by Frank Meeres

Price: £12.99
ISBN: 978-1-84868-456-0

Available from all good bookshops or from our website
www.amberleybooks.com